BONSAI

A Comprehensive Guide to Growing, Pruning, Wiring and Caring for Your Bonsai Trees

By Daiki Sato

By reading this document, the reader agrees that under no circumstances is the author responsible for any losses, direct or indirect, which are incurred as a result of the use of information contained within this document, including, but not limited to, — errors, omissions, or inaccuracies.

Table of Contents

Introduction.. v

Chapter One - Basic Bonsai Styles 1

Chapter Two - Types Of Bonsai Trees 26

Chapter Three - Necessary Tools........................... 43

Chapter Four - Planting And Soiling 65

Chapter Five - Fertilizing And Watering............. 81

Chapter Six - Wiring Techniques........................... 97

Chapter Seven - Pruning And Trimming........... 116

Chapter Eight - Presenting Your Bonsai............ 133

Final Words... 142

INTRODUCTION

Bonsai is a botanical art form used to cultivate small trees to the shape of larger trees. Although the roots of this horticultural practice originated with the Chinese art of penjing (tray planting), the Zen Buddhists of Japan laid the foundation for modern bonsai gardening more than a thousand years ago. The word bonsai in Japanese is made up of two parts: bon (盆) meaning "tray", and sai (栽) meaning "planting". The literal translation of the word bonsai means "planted in a tray".

The trees used in bonsai gardening are kept small through a variety of different techniques; this includes pinching buds as they develop, pruning away branches or wiring them together, and a very careful use of fertilizer and nutrients. Bonsai trees are typically between five to ten inches tall, although the trees used in bonsai are rarely dwarf species—their height and size is due to careful maintenance rather than genetics. Since bonsai gardening can be done with many different types of trees, it helps to understand the key attributes that a bonsai gardener looks for in a species. Bonsai trees should have pronounced trunks, must sprout proper branches, and must be able to survive within a container despite the size and subsequent cramping of its roots.

These key attributes leave gardeners a lot of wiggle room, and many different and unique bonsai trees can be grown because of this.

As bonsai gardening has filtered down to the public through its original lens of Zen Buddhism, the practice has taken on multiple meanings and connotations. A basic understanding of these terms can help to clarify bonsai gardening to those unfamiliar with this historical practice. First, calling these plants "bonsai trees" is a little misleading. Since the type of plant a bonsai gardener uses is treated to look like a tree, they don't technically need to use a tree at all. A tree crafted by a skilled bonsai gardener will share enough of the natural features of a tree to "trick" the observer. Bonsai gardening is traditionally done in a clay pot or tray (per the name), and the bonsai plant is always kept smaller in the container than it would be if planted normally. Bonsai gardening strives to create a feeling of natural cultivation despite being engineered through pruning, trimming, and care from the gardener. A proper bonsai tree will be presentable while hiding the fact that it is a presentation.

On a more profound or spiritual level, the Zen Buddhists who invented bonsai gardening thought of the plants as something more than a simple tree. The trees that they grew were representations—pieces of artwork that an audience would then be able to interpret. In this way, the bonsai tree had more in common with a

painting than with other plants, and it relied on the unique experiences of the individual for its meaning. Since bonsai trees are kept in a container and require a lot of attention, this practice also served as a tool for teaching compassion and selflessness. Another meaning attached to the bonsai was a sense of honor and respect. Taking a piece of the outside world and bringing it into the home was seen as a way of honoring nature and the natural world; and this sentiment is honored to this day.

While each of these points helps us to understand what bonsai gardening is and why it exists, they hide the most important reason that this practice has caught on outside of Zen Buddhism and Japan. That reason, simply put, is that bonsai trees are gorgeous. They can be used to add flavor to a room or create a sense of peace in any given space. Bonsai gardening requires attention and care over a long period of time, and this makes it a fulling and relaxing hobby—a way to unwind after a hard day and to focus attention on something of natural beauty.

In this book, you will learn about basic bonsai styles and the types of trees most often selected by bonsai gardeners. Chapters one and two will serve as your introduction to bonsai gardening. As you'll see, the many different styles of bonsai pruning create beautiful emotional effects that can change depending on the species of tree being used. The interplay between style and species creates one of the most interesting aspects

of bonsai gardening. The ability to change the emotional effect of a bonsai presentation clearly shows how this horticultural practice is really just a form of art in disguise.

In chapters three through five, we will begin the hands-on lessons about bonsai gardening from a horticultural perspective. Following the discussion on styles and species will be a look at the tools necessary for bonsai gardening. Everything you need to look after and care for your bonsai tree will be covered in this chapter so that you can create a shopping list to get started gardening. From there, we move onto planting and soiling. From seed to repotting, you will watch as your bonsai tree comes to comes to life and grows. This will be followed by a chapter on fertilizing and watering where you will learn how often to feed and water your bonsai tree.

Chapter six through to the end of the book will look at bonsai gardening as an art form. Chapter six will discuss wiring techniques, which is one of the ways that we control the growth of a bonsai tree; but more importantly, it is one of the key techniques used to style bonsai trees. Chapter seven will move on to pruning and trimming. Both pruning and trimming are used to control growth as well as keep the style in check. Finally, chapter eight will leave behind questions of growth and focus entirely on the presentation of your bonsai tree in

order to create profound reactions inside the emotions of the viewer.

By the time you are finished with this book, you won't just know how to grow a bonsai tree—you will know how to make it stand out and create a lasting effect on anyone who sees it.

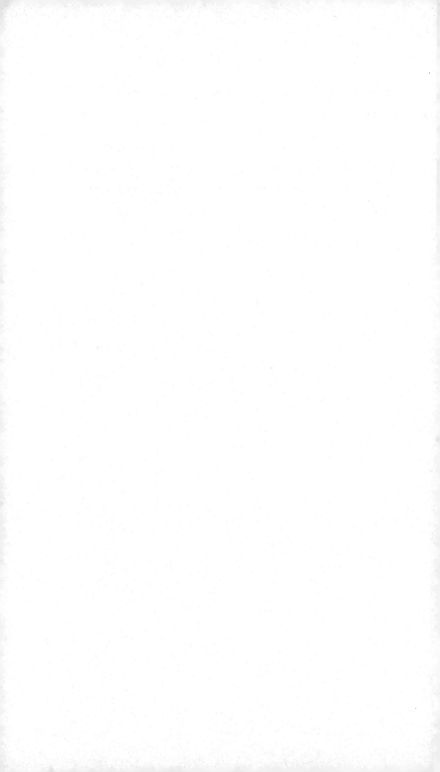

CHAPTER ONE

BASIC BONSAI STYLES

While bonsai trees are smaller than their naturally grown brethren, the many different styles of bonsai all share the same root. Each bonsai style aims to recreate the look of trees found in nature, only on a much smaller scale. Next time you're out on a walk, pay attention to the trees you pass. Do you notice how much variation and variety they have in their size and shapes? Even trees of the same species can have wildly different shapes depending on the circumstances of their growth. Whether they stand alone and stretch out or they're tightly packed together and stubby, whether disease or animal life has contributed to their shape, each and every tree you see will be unique in its own way.

Bonsai gardeners sometimes referred to as bonsai artists, strive to shape and style their plants after those designs most commonly witnessed in nature. In this chapter, you will learn of the many different styles used to achieve this effect. We will begin by looking at the five basic styles of

bonsai gardening: formal upright, informal upright, slanting, semi-cascade, and full cascade. These five styles will give us the foundation we need to look at some common styles that branch off from the basics. We'll even take a short look at a couple more advanced styles before discussing which styles are the best fits for beginners to bonsai gardening.

The Five Basic Styles of Bonsai Gardening

When it comes to the basic styles, it is very easy to understand the naming conventions that bonsai gardeners use. Each style is named based on the angle that the tree is grown in within the container. Of course, this only applies to the most basic styles, so more advanced styles shouldn't be expected to fit this convention. Since the individual bonsai gardener is able to choose the style they want through wiring, pruning and trimming, you shouldn't think of a style as a limitation on what kind of tree you use. For example, a species that is normally upright in style when grown in nature can be wired into a cascading style with effort and care. That said, beginners should try to keep their style and species compatible until they know what they are doing.

1. Formal Upright Style

The first style is the formal upright style, known in Japanese as *chokan*. When trees are grown in nature without a lot of stress to alter its growth (such as disease or cramped spaces), they like to fill out in an upright style. The chokan style is considered to be formal because of the angle and position of the tip of the tree in comparison to the trunk. A formal upright style has a trunk that points directly skyward with the apex of the tree being directly located over the center of the trunk. If looked at from the side, a bonsai tree in the formal upright style almost has the appearance of an arrow. As the branches poke out from a tree in the formal upright style, they should be tended to create a pyramid shape. The lowest branches should be the longest and every successive layer of branches should be trimmed to be shorter. This goes all the way to the top, which will then serve as the final layer of branches (despite the fact that it is actually part of the stem).

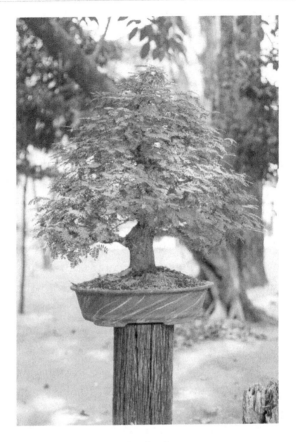

2. Informal Upright Style

The next style is also grown in an upright manner, but with no emphasis placed on creating a straight trunk. Called the informal upright style, known in Japanese as the *moyogi* style. The informal upright style is almost certainly the most common style chosen by beginner bonsai artists. While the formal upright style strives to recreate the appearance of a wild tree that had no

stresses, the informal upright style recreates the shape of a tree whose growth has been controlled by the elements. The informal upright style has a trunk that shows lots of twists and turns. In nature, this happens to a tree when the trunk itself is broken due to rain, wind, or snow—although animals may also be responsible for the damage in some cases. A tree heals similarly to the human body: if you break your arm, you go to the hospital and get it set in a cast so that everything is where it's supposed to be while the body heals. In the wild, no one can put a cast on a tree that has broken or damaged, so the tree repairs itself the best it can. This results in weird twists and turns once the tree is healed. Rather than growing straight upwards, these trees tend to sag to the left and right. This in turn has an effect on the way branches grow, as they tend to sag downwards rather than outwards. Bonsai gardeners that want to follow the informal upright style either select trees that already show this kind of damage, or they control the growth of the trunk through thoughtful and attentive wiring techniques that you'll learn in chapter six.

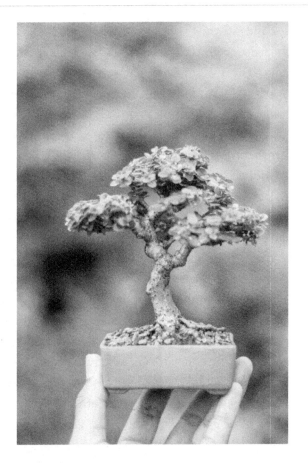

3. Slanting Style

The third style is the slanting style, known in Japanese as the shakan style. This particular style can be quite difficult to achieve and isn't recommended for beginners. As the name implies, trees in this style have a distinct slant to them reminiscent of the Leaning Tower of Pisa. While it may seem like an unnatural approach for a tree, it does still take its inspiration from nature.

Trees that are grown in areas where they are often buffeted by the wind from a single direction will begin to lean. This shape can also be caused by forceful running water like a river. Since there is a lot of force pushing the tree in one direction, it leans that way in order to go with pressure rather than against it, which would cause more damage. In addition, this often allows a tree to get more of the precious sunlight it needs to continue growing. The latter point is important since the roots of the tree need to be thick and strong enough to hold it up. If a tree leans to the right, the roots on the left side are going to need to grow heavy enough to prevent it from toppling over, and vice versa. For a bonsai artist to achieve this work requires careful wiring and a mindful appreciation of how trees look when leaning in nature. This approach can yield a beautiful bonsai tree, but one that requires the utmost attention and care.

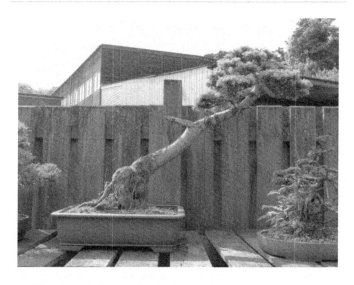

4. Semi-Cascade Style

The fourth style is called the semi-cascade style, known in Japanese as han-kengai. This style, as well as the next one we'll see, is inspired by trees that have grown up on cliffs near a river or by the sea. Since the cliffsides don't get a lot of water, a thirsty tree's branches will grow out towards the water so that it can drink. If you have ever seen a movie in which someone dangles from a tree branch over a river to save a friend, family member, or pet, then you should have a decent idea of how this style appears when in nature. When it comes to bonsai gardening, there are a few rules that need to be followed to create the proper semi-cascade style. The tree must grow outwards from the pot. While the informal upright style and the slanting style might both produce a tree that hangs over the edge of the container,

they aren't designed to do this specifically; rather, it is a possibility that may occur when working with slanting or informal upright. With the semi-cascade style, going over the edge of the container is a requirement. Where the semi-cascade style most differs from previous styles is the angle at which the trunk grows. While the informal upright style points upward and the slanting style points up and outwards in a diagonal direction, the semi-cascading style grows sideways and down so that it pushes past the edge of its container and points down towards the floor. Despite this, the semi-cascade style should not extend below the base of the container that the tree is in. If it does so, then it is no longer a proper semi-cascade style bonsai tree.

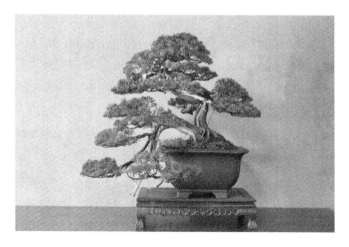

5. Full Cascade Style

The fifth and final of the basic bonsai styles is the full cascade style, known in Japanese as the *kengai* style. In nature, the full cascade style can be found in the same areas as the semi-cascade style. The primary difference between the two is dependent on whether or not the cascading line extends past the base of the container the bonsai is grown in. Bonsai trees grown in a full cascade style need to be placed on an elevated stand to prevent the trunk and branches from just resting on the floor. Grown through the use of wiring and trimming, neither the semi-cascade nor the full cascade styles should be allowed to touch the stands on which their containers rest. Of course, the individual grower might take exception to this rule, but to do so is to ignore the art of the bonsai and would be akin to trying to paint the *Mona Lisa* with crayons instead of oils. To those that understand the artform, it would be an aberration and perversion of the form.

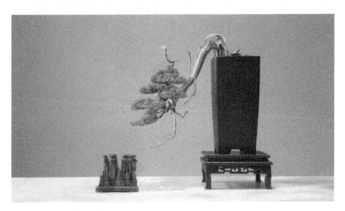

Other Styles Used by Bonsai Artists

While most, if not all, bonsai trees can be divided into the five main styles we've just covered, there is still a lot of variation to be found within each category. The styles looked at so far might be best considered in terms of "genre." When it comes to movies there are genres like action, romance and horror. But within the overall genre are different styles or subgenres used to further break down the category. In horror, for example, you may have the paranormal, the slasher, or the monster movie. In action there are movies that focus on kung fu, and others that focus on gun battles and car chases. While each of these subgenres is still part of the primary style, they have their own sets of rules to follow. Bonsai artistry works in exactly the same way, as these styles will show you.

1. Broom Style

The broom style is a popular modification of the formal upright style that is designed to look like the trees you would find in an orchard. In order to properly achieve the broom style look, the type of tree chosen needs to be deciduous. This means that it sheds its leaves every year, as you expect to see in nature during the autumn and winter. The branches of a tree in the broom style are made to grow up and outwards to form a crown around the top of the trunk. The branches are encouraged to split apart as they grow outwards, which gives a tree in the broom style a very distinct look. When

done properly, broom style bonsai trees look much older than they actually are. The most common approach to the broom style is to stick with the formal upright style and keep the trunk straight, although the broom style can work well in a more informal upright style if so desired.

2. Exposed Root Style

An entirely different style than those explored so far is the exposed root style, or the root over rock style. The exposed root style is found in nature when the elements erode or otherwise remove the soil a tree is growing in so that the roots are visible. When brought into bonsai, the exposed root style can be controlled in such a manner as to really open up the roots to view and this can create really impressive plants that show off a part of the tree that normally isn't visible. Bonsai gardeners need to take their time and really work hard to create this style as only a small amount of the root can be exposed every year and still keep the tree healthy. This makes the exposed root style a long form bonsai project.

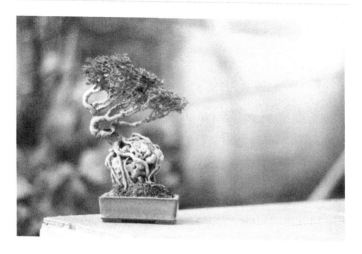

3. Root Over Rock Style

The root over rock style forms in nature by pure chance. When a tree's seeds are ready to drop, animals or the elements are responsible for helping them spread out. Sometimes those seeds end up stuck in the crack of a rock. If it can find enough soil to get its roots in place, then you can see one of the most beautiful sights that nature holds. A small tree poking up out of a rock is a beautiful sight, but even more gorgeous is the way that a tree's roots can grow to spill out over a rock and down its sides to get at the nutrient filled soil. This is recreated in bonsai artistry by carefully controlling the placement of roots during placement. One approach is to bury a rock in the soil prior to planting. Bonsai trees in this style will develop a root system that wraps around the rock, and the technique of the exposed root style can be undertaken to show how the roots have taken to the

rock. This beautiful style takes patience and time, but the results can be breathtaking.

4. Weeping Style

The weeping willow is a species of tree that is adored throughout the world. The way that the branches hang down to wrap around the trunk almost like a warm blanket has turned the weeping willow into a favorite hangout spot for children and provided plenty of privacy for lovers. While the willow isn't the only tree that weeps, it is the most widely known. Weeping trees are most often found in areas that hold onto a lot of dampness such as swamps or streams. In the world of bonsai gardening, these trees are represented through the weeping style. This style uses careful wiring techniques to pull down the tree's branches in a weeping fashion. However, to do this directly would create the wrong effect, so it is important that the branches are first wired to bend upwards before then taking a heavy downward turn. When done in this fashion, the weeping style continues to grow up and out as well as down.

The "Sixth Genre" or Bonsai Gardening

Before we turn our attention towards figuring out what style is the best for a beginner, there is another collection of beautiful styles that should be highlighted. While they aren't grouped together in any real fashion, they could be thought of as a sixth genre of bonsai trees. This "sixth genre" includes the double trunk style, the

raft style, the clump style, and the forest style. What these styles have in common is that they are designed using more than just one tree. While it may not be 100% true biologically, the aesthetic results are astounding.

1. Double Trunk Style

The double trunk style can actually be a single tree with two trunks, so this style is an actual biological entity. But to those looking upon it, the double trunk style looks like two trees grown together in a container. That said, the double trunk style is often done with two trees that have different measurements, but which are grown together around the base and then treated like a single plant. This can be done by using one or two types of trees, but their bases need to be planted at the same point so that there isn't a clear divide to an outside observer. These trees can be grown in the formal upright, informal upright, slanting, or even semi-cascading styles, although the informal upright tends to be the most common. Regardless of which best describes a bonsai plant grown in the double trunk style, it is important to note that the space between the two trunks is kept clear. Branches that begin to grow in this middle section are trimmed off in order to preserve the aesthetic.

2. Raft Style

The raft style is a unique take on bonsai. When a tree is knocked over in the wild, it doesn't necessarily mean that it has died. The roots from the trunk can still continue to grow, and this leads to an odd sight: a tree that continues to grow while laying down. The branches on the bottom side of this tree aren't able to grow anymore, so energy is diverted to growing the branches on the side facing up. Given enough time, these branches start to look like young trees growing up from the ground instead of from off of a tree themselves. Bonsai artists recreate this natural occurrence by laying a tree on its side (typically a one-sided tree to begin with). The bark on the bottom side of the tree is opened up to allow access to the cellular tissue from the tree's cambium layer so that a rooting powder may be applied. If the trunk of the tree being used in this manner is straight then the branches will tend to form in a straight pattern while a trunk that is curved will create its own, unique effect.

3. Clump Style

In nature, you get a clump of trees together when a few seeds land next to each other in an area with plenty of nutrients in the soil. Since the soil is healthy enough to provide enough nutrients to more than one tree, they start to grow up together. As the seeds are for the same type of tree and have fallen at the same time, this means that the growth among the trees will happen at the same time. When these criteria are met, you end up getting a

clump of trees that began separately but grow to merge together. Multiple trees can join to become a single larger tree that has several trunks rather than just the one. When this happens, the trees naturally need to start to grow their branches outwards and away from each other. This is done in order to get as much sun as possible. Bonsai gardeners recreate this style by starting their trees from seeds or seedlings that have are tightly grouped together. These trees form naturally, so the bonsai artist only needs to focus their attention on the wiring of the branches.

4. Forest Style

Finally, we come to the forest style. This is achieved by using anywhere from five to twenty small trees to create the impression of a forest in a container. This style allows for lots of possible presentations such as being made to look like it extends into the distance by layering trees of different sizes. This effect can be reversed by planting smaller trees in the middle and larger ones on the outside to give the impression that one is walking through a forest. This technique requires paying special attention to the roots and the needs of the tree species being used, as it achieves its best effects by using species with different heights, trunk sizes and branches. Bonsai artists strive to create forest styled presentations in which no three trees look to be in a straight line regardless of the angle the display is viewed at. This

approach is difficult, easily the hardest that we've looked at, so it is not recommended for a beginner.

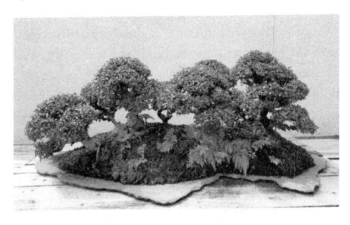

What Style is Best for Bonsai Beginners?

The goal of bonsai is to create the look of a tree in nature within your container. To this end, there are some styles like forest, raft, or double trunk that result in unique and intricate bonsai creations. However, the difficulty of these styles makes them a poor fit for the beginner who is just getting started with their first bonsai creation. It is best for the beginner to stick with a more easily tended style.

That said, this shouldn't be taken to mean that beginners can't make beautiful bonsai artworks of their own. Even the simplest of designs can have a profound beauty to them, making it easy for the beginner to see why the bonsai art form has lasted for more than a thousand years. One of the biggest things that bonsai

teaches is patience. We can't force our trees to grow any faster than they do. This patience should be considered a lesson for the beginner. If you want to create a more complicated style of bonsai, then you should first demonstrate patience and build your skills through one of the three styles listed below. It might mean it takes longer for you to get around to the creation in your head, but you will be able to build up the skills you need to properly wire and tend a difficult style of bonsai tree. Until then, consider starting with one of these three.

The Broom Style: Typically done as a formal upright style with special attention paid to the way the branches fan out on top, this is one of the easiest bonsai styles for beginners. The trunk is left to grow up naturally without any stress put on it, meaning there is less for you to wire up. The primary work done in maintaining a broom style bonsai arrangement is to trim away branches and clip the leaves as needed. All you need to manage this is a pair of shears, although a concave cutter can also be a beneficial tool for a broom style bonsai tree. Since you don't need to worry about wiring this up, you can keep a broom style bonsai tree looking beautiful with minimal work.

The Informal Upright Style: The informal upright bonsai style looks gorgeous when it is done properly, but it takes a good deal more work than the broom style does. This makes it a great choice for the beginner who is looking to get into bonsai gardening but still enjoys a

challenge. The informal upright style can be achieved through pruning and trimming alone, but most gardeners are going to want to do some minor wiring in order to promote growth in different directions. The wiring involved in the informal upright style shouldn't be done to excess, as this style is still using the tree's naturally growing habits to achieve its look. This allows the informal upright style to be a good introduction to bonsai wiring.

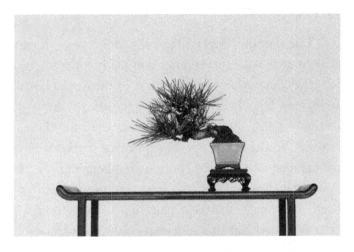

The Literati Style: The idea behind the literati style is to show "the essence of a tree." That is to say that this style pares everything down. There are almost no branches allowed on a literati style bonsai tree and many gardeners consider the literati to be a difficult style to perfect. That said, it can make for a great introduction to beginners looking for a crash course on bonsai gardening. The literati style is inspired by those trees that

shouldn't be alive; that lone tree that can't grow very tall because the elements keep beating it down and there aren't a lot of nutrients for it to feed on. Yet, despite these factors, the tree continues to live and grow. The literati style requires very little wiring because it relies on almost no branches. Most trees grown in the literati style are kept with fewer than five branches. Since the branches only need minima. wiring to give them the appearance of a battered tree in the wild, the majority of the wiring that is done is typically undertaken to control the growth of the trunk itself. Because the literati style is so minimalist, it can be easy to mess it up. Bonsai trees with a lot of leaves and branches can easily be shaped to hide imperfections, but the literati style doesn't offer this flexibility. Getting the literati style just right takes a lot of work, but the minimal wiring required makes it a good start for beginners.

If I were to recommend one of these three styles for your first, I would go with the informal upright style. It can be a little bit tricky at first because it requires more maintenance than the other two styles, but trees grown in the informal upright style have a very unique look to them that adds charm to any room in your house. The informal upright style also gives you a chance to start working with wires earlier than you would with the broom style, but the foliage adds more texture to the entire creation when compared to the literati style. Whichever you pick, you will still need a tree and some tools, and it is here we turn our attention to next.

Chapter Summary

- The goal of bonsai gardening is to recreate the look of a tree as it is found in nature in a miniature form in a small pot.

- Bonsai gardeners are sometimes called bonsai artists because it is both an artform and a horticultural practice.

- Bonsai styles are named as descriptions of how the tree leans.

- The five main styles of bonsai are the formal upright style, informal upright style, slanting style, semi-cascade style, and full cascade style.

 o The formal upright style has a trunk that sticks directly upward.

 o The informal upright style has a trunk that twists and turns but is still primarily growing upwards.

 o The slanting style has a tree leaning style like a 45-degree angle.

 o The semi-cascade style has a trunk that leans down over the bowl.

 o The full cascade style is a tree that has fully spilled out of the container and is growing downwards but not touching any surfaces.

- Beyond the five main styles are a bunch of different styles which function as modifications on the basics.

 o The broom style is a version of the formal upright style in which the branches are raked upwards to look like the bristles of a broom.

 o The exposed root style uses care and patience to create a bonsai arrangement in which the root is exposed over many years so that a large section of it is visible above the surface of the soil.

 o The root over rock style sees the roots of the tree spill out from overtop of a rock so that they are both in the dirt and exposed.

 o The weeping style recreates the looks of a tree like the weeping willow.

 o The double trunk style is most commonly a tree with two trunks growing up alongside each other. It is also a signature of this style that the space between the two trunks is kept free of branches or leaves.

 o The raft style recreates the look of a tree that has fallen over in nature so that the branches on one side are sticking up like a line of trees in their own right.

- o The clump style is a cluster of trees of different species clumped together and arranged in intriguing ways.

- o The forest style is an arrangement of five to twenty trees that have been made to give the impression of being inside of a forest.

- The three easiest styles for beginners are the broom style, the information upright style and the literati style, which is a tree reduced to its "essence."

In the next chapter, you will learn about the different kinds of trees most commonly used by gardeners looking to create their own bonsai artwork. You'll be introduced to a selection from the more than 130 species used for bonsai gardening and learn the difference between deciduous, broadleaf evergreen, and conifer trees.

CHAPTER TWO

TYPES OF BONSAI TREES

While bonsai practices are strongly rooted in Japan, the types of trees used in this style are not limited to those found on the island. The Chinese art form penjing, which is an older form of miniature landscaping, often includes trees that are remarkably similar in display to those of the bonsai art form. But more than that, bonsai gardening has spread across the world, and this has led to many different tree species being grown through and for the purposes of bonsai arrangement.

A quick look at Wikipedia's "List of species used in bonsai" article reveals that more than 130 different kinds of trees that have been used for bonsai so far. This list shouldn't be considered anywhere near complete, as there are bonsai artists experimenting with new species every day. We won't be able to look at nearly all of these species here, nor would much be gained by doing so. Rather, we will look at those species that are either the most common or the most beautiful.

In order to provide some structure to our exploration of bonsai trees, we will be dividing the species up into three categories: deciduous trees, broadleaf evergreens, and conifers. Deciduous trees have already been mentioned; they are the type of tree that sheds its leaves in the fall, which makes them the best possible choice for a bonsai tree in the broom style. Broadleaf evergreens hang onto their leaves throughout the entire year and these will make up our second category. Pines and conifers are any variety of needle-leafed or scale-leafed tree, such as spruces, pines, or junipers. The order of category does not in any way reflect the quality or charms of the trees found within it, and the ultimate choice of which to use is up to a combination of your aesthetic taste and the style you want to use it in.

Deciduous Species

Using a type of deciduous tree in your bonsai arrangement means that starting in the fall, your tree will begin to lose leaves. These won't begin to regrow until the spring. Arrangements that are dependent on leaves can look rather silly during the off-season, although the changing color of the leaves is a beautiful sight even when done in miniature like bonsai. On the other hand, some styles (like the broom style) are best displayed when the leaves have fallen off and the intricate patterns of their branches can be displayed. Well-known deciduous trees include maples, elms, and oaks.

Although we will be looking at a couple of these types, there are dozens of different deciduous species which can be used.

Japanese Maple: These bright and beautiful plants are often among the finest used for bonsai arrangements. They are also one of the more popular species that bonsai artists select thanks to the colors they take on in fall. The leaves of a Japanese maple may be green at times, but more often they come in shades of red and pink, and turn to yellow and orange throughout the fall. A Japanese maple doesn't take much maintenance when compared to some of the other species that we will see, and this makes them a great choice for beginners. If you are getting into bonsai gardening because of the beauty of the craft, then a Japanese maple makes for one of the best species you could choose.

Weeping Willow: As we've previously discussed, weeping willows are a favorite type of tree around the world because of the unique, bell-like shape that is caused by the way the branches hang down. This popularity makes it easy to get your hands on a weeping will tree at just about any local gardening center. If you choose to go with a willow when picking a tree, then you can expect this bonsai creation to last for a quarter of a decade if properly tended to. You may think that the weeping willow would be the best fit for a semi or full cascade style arrangement, but the way their trunks twist and turn naturally actually makes them one of the best choices for bonsai arrangements in the informal upright style.

Japanese Cherry Blossom: Even if the name of this species didn't tell you where it was from, you would be able to tell this tree was from Japan just by looking at it. Japanese cherry blossom trees have been a part of Japanese artwork, poetry, and history for as long as they have had the written word. These trees are from the same family as peaches and almonds, and yet they don't actually grow cherries. Instead, Japanese cherry blossoms are grown for the beautiful pink flowers they grow, referred to as *sakura*. These beautiful trees can be difficult to shape and will require extensive pruning and wiring, regardless of which style you decide to go with.

Cherry Tree: While the Japanese cherry blossom doesn't grow cherries, this doesn't mean that you can't go with a more traditional cherry tree. Save your seeds next time you have some cherries and you might be able to grow one of these yourself, although many growers would suggest using specialized seeds. However, much like their Japanese cousins, these trees can be a hassle to grow. If you want to actually grow cherries on your bonsai tree, this will make the growing process more difficult, as you need to learn the proper technique for shaping the cherry tree as a bonsai arrangement as well as the horticultural techniques required to bring a cherry tree to fruit.

Oak: There are hundreds of different species of oaks out there, so many that it becomes almost ridiculous as there are more than 500 that come from

South America alone. If you are considering working with an oak tree for your bonsai arrangement, then you will need to do a little extra homework and make sure that the species of oak you are looking at can be cultivated in a bonsai style. There are quite a few that can't, although this shouldn't be a surprise with how many there are. Those species that can work in bonsai arrangements are ideal for growers. Oaks are a more challenging species to work with than maples or weeping willows, but they do look wonderful. The reason for this challenge doesn't come from wiring the branches like you might expect, but rather it is due to the way that their roots need to be pruned. Oak trees have very picky roots and they need to be tended to in a unique fashion. If you are game for the challenge, then growing a bonsai oak can be a rewarding experience.

Broadleaf Evergreen Species

This type of tree doesn't lose its leaves during the fall like deciduous trees do. Instead of shedding all at once, broadleaf evergreens instead let go of their leaves throughout the course of the year, but they never let go of so many leaves as to look barren. When a broadleaf evergreen lets go of a leaf, it is because they are starting the process of growing a new leaf in its place. This behavior makes trees of this type a perfect fit for bonsai styles that focus on the shape and design of the foliage rather than the branches. A broom style would still look good with a broadleaf evergreen, but it wouldn't have

the same appeal it does when a deciduous tree is used. A semi or full cascade style on the other hand would look much better with a broadleaf species since losing its leaves would leave it with an odd appearance without many charms.

Fig Trees: Among the most popular choices for bonsai, there are actually hundreds of different types of fig trees. The most common variety seen in bonsai is the *ficus retusa,* which naturally has a trunk that twists into an almost S-shaped way. Some figs may produce flowers though this isn't common among all species. What is common is a sap that will leak out from any cuts or scratches in the tree. This sap can be messy to deal with, so it is recommended to be careful when pruning and trimming a fig tree. Because many fig trees actually produce visual roots in order to get enough oxygen, they are among the best choices for root over rock or exposed root styles of bonsai. The branches of a fig tree are easily wired thanks to their flexibility, and those fig trees that are grown with roots in the soil are easy to care for. To properly achieve a style with the roots exposed, fig trees need to be provided as much humidity as possible. While this can be hard to achieve for the beginning grower, it can be quite beautiful to grow a fig tree in this style by using a glass case to trap humidity in. When this effect is achieved, it gives the bonsai arrangement a fairy tale like quality.

Jade Trees: Jade trees are fantastic choices for bonsai beginners thanks to their low maintenance when compared to many of the other species we've explored so far. The jade tree is actually a succulent, which is a type of plant that stores water inside of its leaves so it can survive dry and/or drought conditions. Succulents like this need less watering than other plants, and that means less time spent taking care of a jade tree in the long run. Jade trees will require a soil that is fast draining and has lots of coarse components like sand or gravel mixed throughout it. What this means for a bonsai arrangement is that a jade tree is best used for a more barren presentation that makes liberal use of rocks to add color and texture. So long as you can provide a jade tree with the appropriate soil it is among the easiest species you can start with. It is best done in either a formal or informal upright style.

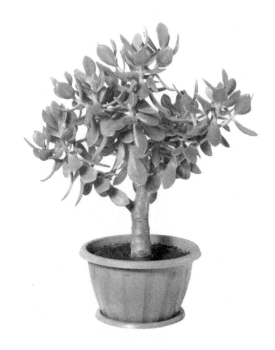

Bonsai Money Tree: Unfortunately, despite the name, money doesn't grow on this type of tree. The name for this type of tree, known in Latin as *crassula ovata*, comes from what it represents. A money tree is supposed to bring good luck and prosperity to the home it is grown inside, and many bonsai gardeners grow their own in hopes that it will bring them wealth. The bonsai money tree has an intricate and beautiful trunk that begins as separate pieces that then twist and spiral around each other as it grows upward. The trunk turns from brown to green the higher it gets, and leaves act as a hat upon the top of the plant. The bonsai money tree

34

is most commonly grown in the formal upright style, as it is in this style that it is supposed to work its magic and invite money into your life.

Pines and Conifers

It might be a bit redundant to refer to this category as "pines and conifers" because technically a pine is a type of conifer, since it is a member of the family *pinus genus*. However, since pines are often discussed as their own category, it is fitting to think of them separately when considering bonsai gardening. Conifers are a form of evergreen tree, but instead of bearing leaves they produce needles and they spread their seeds through cones. Beyond just looking neat, pinecones are actually the tool for conifers to reproduce and spread out across a forest. We'll close out this chapter with a look at these trees before moving on to the tools necessary to properly prune, trim, wire, and care for our bonsai trees.

Juniper Bonsai: Among the most popular species for bonsai gardening, the juniper bonsai tree comes in over fifty different subspecies. This variety has also allowed the juniper bonsai to spread over the world, with at least one species found on each continent. Seeing that bonsai gardening comes out of Asia, it shouldn't be a surprise to learn that the most common choices for bonsai artworks are the Chinese juniper tree and the needle juniper tree. Both of these varieties of the juniper are quite easy to take care of, making them a fantastic choice for bonsai beginners and experts alike. The

juniper tree is able to withstand many different environments so long as gardeners are careful to provide the proper light and watering. Whether you want your bonsai tree to be indoors or outdoors, the juniper is a fantastic choice both for its ease of maintenance and its striking beauty.

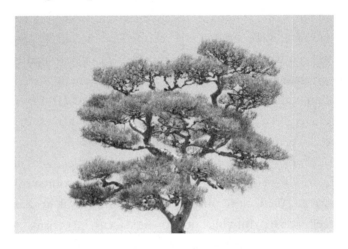

Japanese Black Pine: The Japanese black pine is a staple of the Japanese culture, as it has been a popular choice for addition to the country's architecture designs for decades. The Japanese black pine is notable for the way that its pines grow. The needles on many pine trees hang down, as gravity uses their weight to pull them towards the center of the Earth. But the needles on the Japanese black pine are very delicate and they most often grow upwards towards the sky. These needles also grow in pairs rather than individually, which helps to create a sense of "fullness" to the tree that works especially well in bonsai arrangements. Beautiful all year round, this

species also grows gorgeous little red flowers during the spring which then turn into cones as the season changes. Those cones can be used to plant more trees, although most bonsai gardeners choose to trim them away to maintain the right balance in the shape of their trees. While quite as simple to raise as the juniper bonsai, the Japanese black pine bonsai is able to withstand rain and winds due to the fact it is naturally drawn towards shorelines and bodies of water. This makes it a great choice for both indoor and outdoor placement without having to worry about it breaking or being damaged in a storm.

Cedar Bonsai: Cedars have a very interesting style to them, with their tan colored bark that cracks and breaks. They love to grow straight upwards, making them a perfect fit for arrangements in the formal upright style. The straight shape of their trunks also makes them a good fit for the slanting style arrangements, where the majority of the trunk is allowed to grow straight but at an odd angle. Branches on cedar trees don't grow particularly large, but the clusters of needles on them are tightly packed together. This makes the cedar a great choice for those looking to fit a bonsai tree into a tight location, perhaps due to limited space or because it is a part of a larger arrangement of several plants. However, it must be noted that cedars can be quite difficult to take care of when done in bonsai fashion. This difficulty further manifests itself in how tough it can be to find a bonsai cedar since a lower demand makes them a less

profitable item to stock. If you are ready for a real challenge, a cedar can be a hard tree to control but one that is truly rewarding and makes for a unique sight among bonsai artists. That is, they are rewarding so long as you are able to find one.

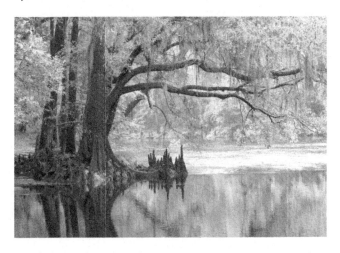

Bald Cypress: If you are looking for a bonsai tree that you can take care of for the rest of your life, then the bald cypress is a perfect choice. In the list of oldest trees in the world (that is, oldest individual trees whose ages are known to scientists), the 9th oldest is a bald cypress from North Carolina, USA. That particular tree is over 2,500 years old, and there are many other bald cypresses which are over 1,000 years old. The trunk of the bald cypress is a tan color, similar to the cedar, but without the cracking layer this species is known for. Found naturally growing in wet conditions such as alongside rivers or even in swamps, the bald cypress is

an odd conifer. Most conifers are evergreens, keeping their leaves throughout the year, but the bald cypress is a deciduous and sheds its needles in the colder months. Bald cypress trees have longer branches than cedars, and while their needles aren't as tightly packed together they do grow in a pair of rows along the branch to create a solid canopy. Provided with plenty of water, you can expect to keep a cypress tree alive throughout your entire life, and even the life of your descendants if you are mindful of its health. While the bald cypress tends to take on a circular shape when grown in the wild, most bonsai gardeners prune these trees to create a rotund shape. When done in this fashion, the green of the bald cypress looks almost like an opaque version of the fig tree's glass cover.

Chapter Summary

- There are more than 130 species of tree used in bonsai arrangements and they come from all across the world, not just from Japan where the practice originated.

- There are three categories of trees, all of which have unique attributes of their own: deciduous, broadleaf evergreens, and conifers.

 o Deciduous trees have leaves which change color in the autumn and start to fall off, so the branches are barren during the dormant colder months.

 o Popular deciduous trees for bonsai gardening are:

 ▪ Japanese maples, which don't take a lot of maintenance and are a great choice for beginners.

 ▪ Weeping willows, which are perfect for the information upright style.

 ▪ Japanese cherry blossoms, which have beautiful pink flowers that the Japanese call "sakura".

 ▪ Cherry trees that can actually grow cherries, which takes a lot of work.

- Many different types of oak trees, which look beautiful, but require a lot of root maintenance.

○ Broadleaf evergreens are trees which shed their leaves throughout the year while new ones continue to grow so that they are never without their leaves, so they don't fit well with barren styles like the broom style.

○ Popular broadleaf evergreen trees for bonsai gardening are:

- Fig trees, which are difficult but survive well and look amazing in a glass case display to trap humidity in.

- Jade trees, which are succulent that thrives on drier conditions.

- Bonsai money trees, which are supposed to bring wealth to the home they're grown in.

○ Conifers are a type of tree which keeps their foliage throughout the year, but instead of leaves they produce needles and they drop seeds in the shape of cones.

o Popular conifer trees for bonsai gardening are:

- Juniper bonsais, one of the most popular species used in bonsai gardening.

- Japanese black pines, this staple of Japanese culture grows beautiful flowers and works well in both indoor and outdoor arrangements

- Cedar bonsais, who have really unique trunks with bark that cracks and peels

- Bald cypresses, which are among the oldest trees alive on this plant and guaranteed to last you your lifetime when properly tended.

In the next chapter, you will learn what tools are required to plant, raise, and care for your bonsai tree. From containers to tools, you will be able to put together a shopping list of everything you need to look after your own gorgeous bonsai tree. These will be divided based on their role in the bonsai gardening process so that you can find the right tool based on the job at hand.

CHAPTER THREE

NECESSARY TOOLS

Perhaps more than any other type of gardening (besides hydroponics), the bonsai approach uses the most tools in order to properly maintain everything. This is due primarily to the fact that bonsai gardening isn't concerned with producing produce, growing garden greens, or furnishing fruits. Bonsai gardening is entirely focused on maintaining the shape and style of the trees grown in this manner. In order to do this, there are a lot of tools with very specific purposes that we are going to be looking at. Of course, if you are just looking to get started and aren't sure if bonsai gardening is for you, then you can save money by only purchasing three tools: a good pair of bonsai shears, a branch cutter, and a wire cutter. Although if you select a bonsai style that doesn't need wiring, then you can even get by without the wire cutters.

In this chapter, we are going to look at all the various tools used by bonsai gardeners, not just those

that beginners might need. While you are a beginner and won't necessarily need these tools, learning about them will let you see how expert bonsai artists form trees into intricate shapes and styles. Even if you only buy the three tools listed above, this will give you the knowledge you need to expand your toolkit in the future if you find that bonsai gardening is a good fit for you.

Before we get into the tools, let us first take a second to discuss the tools that we are looking at here. This chapter focuses on the tools related to bonsai gardening, rather than those related to gardening in general. This means that we will not be talking fertilizer, containers, or soil in this chapter. While each of these are important pieces of the bonsai puzzle, they will be addressed in the following chapters. While they are technically necessary parts of gardening, they aren't unique to bonsai and any gardener with even a beginner's level of knowledge understands that they are a part of growing anything. With that out of the way, let us turn our attention towards tool quality for a moment.

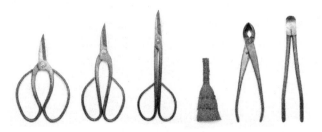

Tool Quality: Are Expensive Tools Worth the Investment?

When it comes to bonsai gardening, similar to many specific manual practices, it is important to match the right tool to the right job. Consider surgery and what would happen if your surgeon decided to open you up with a pizza cutter instead of a scalpel. It would be an absolute disaster and, if you even survive, you are most certainly going to be in pretty poor shape. When it comes to our plants, we are essentially performing a form of surgery every time we trim away some leaves or prune off a branch. Selecting the right tool allows us to make these alterations without causing more damage than is absolutely required.

However, selecting the right tool goes even further than this. Trying to use a pair of shears to cut through a branch might work to get rid of the branch, but it is more likely that you will damage your shears. Selecting a branch cutter instead will ensure that the cut is done properly and that your tool isn't damaged. While this may seem like common sense, the truth of the matter is that many gardeners (even those who have been doing bonsai for a long time) are often unaware that they are selecting the wrong tool for a job. While this chapter will introduce you to all these tools so that you can always select the proper one, it is important to consider the quality and price when purchasing your tools.

When it comes to purchasing tools, beginners have a habit of selecting low-quality makes. This is due to the fact that it is always cheaper to purchase a lower-quality tool than a high-quality one. But the money that is saved in this manner will be reflected in their design and the quality of the cuts that they make.

The other issue that beginners may frequently run into is approaching their initial purchases from the opposite direction. Rather than purchasing low quality tools, they go out and they spend lavishly and get every tool they may need in only the highest quality. While this is a better approach than purchasing low-quality tools, it does have its downsides. For one, this approach is extremely expensive. What's more, if you are a beginner, then you might not even enjoy bonsai gardening once you get started. If you have purchased a ton of high-quality tools, it is a real pain to realize that you wasted all that money on a hobby you aren't going to keep up.

The best approach for a beginner is to purchase high-quality makes of the three basic tools mentioned above: bonsai shears, branch cutters, and wire cutters. Begin with a style and species of tree that doesn't require a lot of extra work. These three tools should get you by for the time being and the higher quality will ensure that you don't damage your bonsai tree unnecessarily. To understand the difference in performance, let's compare and contrast an inexpensive tool against a high quality one.

Tools that have been cheaply made have a tendency to be much heavier than more expensive ones. You may think that the weight implies a higher quality because there is more material used in the making of the tool itself, but this actually implies the opposite. Rather than use too much material, high quality tools use better quality material so that they need less of it. This has a practical effect on you, the gardener. A heavier tool requires more strength to use. While this doesn't necessarily impact you when you first start working on your bonsai tree, if you are to work on it for any length of time, then you will find yourself getting tired much sooner than you would with a lighter tool.

While cheaper tools use more material, that material is more often than not of a low-quality itself. What this means, beyond the extra mass, is that low quality tools are going to be much more likely to break or rust. So that lower quality tool you purchased, because it was half the price of a higher quality tool, is going to need to be replaced much more frequently. This effectively reduces or eliminates any of the savings you might have had due to purchasing lower quality. Instead of saving you money, a lower-quality tool may end up costing you more money as you replace it with another. If you replace it with another low-quality tool, then this new tool is also more prone to breaking. If you replace it with a high-quality tool, then you will have spent money on both the high quality and a low-quality tool. It is better to purchase one high-quality tool that will last. You

might not save as much money during the initial investment, but its longevity will save you in the long run.

Just like cheaper tools are more likely to break, they are also much quicker to dull. You want a sharp tool to make your cuts. Consider the human body again. You want that scalpel to be nice and sharp so that it slices through without any problems and makes a fine edged cut. If it were dull, the surgeon would have to apply extra pressure and pull it along your body, which would leave a jagged and rough edge to the cut that slows down the healing process. Your trees are exactly the same, so provide them with the cleanest cut possible. With cheaper tools, this means you are going to need to sharpen them off, and many tools can actually suffer from this. As you sharpen one of the blades on your cutters, it may file it down so that the tool no longer makes a secure and tight cut because one blade is slightly lopsided. The higher-grade material used in crafting high-quality tools will hold onto their sharpness far longer than lower-quality tools do. This doesn't mean that you won't still have to sharpen them from time to time, but rather that those sharpening sessions are going to be fewer and further between.

Finally, poor-quality tools…to put it bluntly, they just suck. Oftentimes, poor-quality shears don't properly close even before they have been sharpened; or branch cutters have poor connection so that instead of cutting

through a branch it just rips and tears at it. Just like you wouldn't want your surgeon to use a mallet during your open-heart surgery, your bonsai tree doesn't want to be bashed and smashed when it is supposed to be cut. Lower-quality tools are going to hurt your bonsai tree much more than a higher-quality tool does, so using high-quality tools is both the most practical and compassionate route to go.

The Tools

While one approach to structuring this chapter would be to alphabetically list the various tools that are used in bonsai, this wouldn't give you a good sense of what tool is used for what. Instead, we are going to look at what tools are used for each step of the bonsai gardening process. This way you will be able to easily find the right tool for the job at hand. For example, if your bonsai style doesn't require any wiring, then you won't need to read the section on wiring tools. But when you start to branch out into a style that does require wiring, you can come back here to read that section without having to sift through a bunch of tools used for pruning or repotting.

The Tools Used in Pruning

When it comes to maintenance performed on your bonsai tree, pruning is going to be the most common process you undertake. Pruning is done to remove branches or shorten branches, to dispose of leaves, or

cut away knobs. Since bonsai gardening is all about the shaping of the bonsai tree, pruning is elevated to a unique position when compared to other forms of gardening. For example, a vegetable garden is primarily pruned in order to promote the health of the plants in question. Infected branches, weaker branches, and smaller vegetables are pruned away to promote the health of the plant and the quality of the yield. Gardeners growing plants for their aesthetic appeal will often prune vertically and horizontally to control the shape of the plant, but mostly this is done to fit a space in a garden and so it isn't about the shape of the plant as much as the size of the plant. Beyond this focus on size, the plant itself is allowed to grow how it likes with branches and leaves sticking out all over.

Bonsai gardeners are very, very particular about where branches are allowed to be or how many leaves are kept present. For example, consider the double trunk style and how branches are not allowed to grow in the middle section between the two trunks. Since there is such a strong focus on the pruning of a bonsai tree, it should come as no surprise that there are a decent variety of tools used in this process. Let's explore these now.

Shears: The most common tool in any bonsai gardener's toolkit is a good pair of shears. While a strong pair of shears can be used to cut a branch, they really shouldn't be used on the thicker branches of plants such as trees. Smaller branches and twigs can easily be

removed with a good pair of general bonsai shears. Bonsai shears tend to come in two designs: general purpose and trimming shears. General purpose bonsai shears are rather durable and are used for the thicker cuttings, while trimming shears are much smaller and best used for getting into tight areas. If you can only go with one pair of shears, go with general bonsai shears. If you can get two, then you should definitely get both general and trimming. However, if you already have or are purchasing branch cutters, then a good pair of branch cutters and a pair of trimming shears are a powerful combination.

Branch Cutters: While a good pair of general-purpose shears can be used to remove the end of a branch where it is the thinnest, a pair of branch cutters is needed to cut through the thicker and harder parts of branches that are closer to the trunk. When general purpose shears are used for this purpose, they leave behind traces of the cutting which look ugly and stand out from the rest of the tree after healing. A pair of high-quality branch cutters will snip through the branch to leave an even cut so that there is no sign of the cut after healing. A branch should only be 1/3rd of the size of the branch cutter blades, which isn't hard to manage when working bonsai; but displays allowed to grow larger may require a thicker set than traditional bonsai arrangements will. There are branch cutters which are designed for specific tasks, though these should be avoided by the beginner. If using a branch cutter alone then a chisel or

other tool should be used to hollow up the cut section to prevent knobs from growing as the tree heals. Or, you could just purchase the next tool to make the task easier.

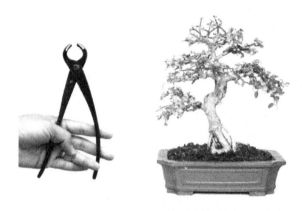

Knob Cutters: After a branch has been cut with a pair of branch cutters, a knob cutter is used on the remaining knob in order to hollow it out and promote a more even healing process. Knob cutters work on the knob the same way that a gouge chisel does, but they are designed to simply open and close like a pair of branch cutters or bonsai shears. When using a pair of knob cutters, it can be very easy to cut off a larger piece of the branch than intended, so you need to exercise caution when first learning how to use this tool. A good idea is to cut off a branch from a tree in the wild and practice using your knob cutters on it. Knob cutters aren't a high priority for beginner's who are building a bonsai toolkit, or at least they shouldn't be. A pair of knob cutters is used for a single task—that of hollowing out a branch

after it has been cut—and therefore it isn't one that provides any utility. That said, knob cutters are the single best tool for the job of cutting knobs and they can make the task a thousand times easier for beginners.

Concave Branch Cutters: A newer tool in the world of bonsai gardening, the concave cutter is a fusion of a knob cutter and a branch cutter. A pair of concave branch cutters is angled in such a way as to both cut through the branch and hollow out the end of it a little in the same cut. Instead of using a pair of branch cutters and then switching over to the knob cutters, concave branch cutters get the job done immediately. While it may seem like the concave branch cutters make the other tools unnecessary, they are limited in their ability to deal with overly thick branches. Branch cutters, on the other hand, can handle these with ease. A pair of high-quality concave branch cutters is also quite expensive, as it takes a lot of precise work to get the blades to make the proper cut in its completion rather than just mostly make it. Whether or not you go with a pair of branch cutters and a knob cutter or a pair of concave branch cutters, remember that quality is important and that the added knob cutting component of a concave branch cutter actually limits the situations in which it should be used while branch cutters offer more versatility for tasks outside of explicitly cutting branches.

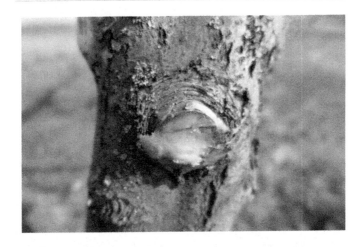

Sealant: There are many sealants available for purchase which can help your bonsai tree to heal after being cut. Returning to the surgery metaphor, you would expect the incision to be covered with gauze afterwards, wouldn't you? So why wouldn't you want to offer the same recovery aid to your bonsai tree? A sealant is applied after a branch has been cut and the knob has been hollowed out. Instead of allowing germs and infection to get into the open wound, a sealant closes up the pathway so that the tree can focus on healing from the wound and not having to both heal from a wound and battle infection at the same time. There are sealants on the market which add growth hormones to help with healing, and these are great for conifers since they are very slow to heal. Hormones can help with evergreens as well, but a deciduous tree doesn't require any extra help in this manner. Whether your sealant includes hormones or not, pick one which sticks where it is

supposed to instead of dripping all over the place. You also want to make sure that your sealant actually makes an airtight seal, otherwise it is a waste of time and money. Some people like to go with a sealant that has been dyed a more earthy color, as a brightly colored sealant can be ugly to look at and break the nature-influenced impression that bonsai goes for. Regardless of color, you want to make sure that the sealant you go with can be easily removed once the wound has healed over. A sealant that you have to chip away at can lead you to accidentally damage the tree again and defeat the entire purpose of using a sealant in the first place.

Tools for Repotting and Root Maintenance

A bonsai tree is still, at the end of the day, a tree. This means that it continues to grow slowly every day. We prune and trim the branches to continue this growth on the part of the tree that we see, but we aren't able to control the growth of the roots. Underneath the soil of our bonsai containers, the roots grow and spread out and eventually they will run out of space. While you may think this means that the tree will no longer continue to grow, this isn't the case. Instead, what happens when the roots run out of space is that the tree starts to become unhealthy and branches will begin to die off.

The roots of a tree need air and water in order to survive, same as most plants do. When the roots have entirely filled the container, there is no more space in the pot for water and air to suffuse. When this happens, the

tree starts to dehydrate and suffocate, and eventually the whole bonsai plant will die. To prevent this from happening, a bonsai tree needs to be moved to a new pot every few years in order for the roots to have more space to move. While you may not need a larger pot to support the weight of the tree the same way that a larger tree raised in containers might, you need a larger pot to allow more space for the growth happening under the soil. The tools in this section help both with repotting and with looking after the roots of your bonsai tree.

Sickle: So, the key reason that we repot our bonsai trees is because the roots have grown to take up too much space under the soil. This fact suggests exactly why transplanting a bonsai tree is such a hassle: the roots are everywhere, holding on and making it difficult to pull the plant out. A repotting sickle is a tool that makes this easier. The repotting sickle slips into the bonsai tree's container along the edges, and a circular motion around the container slices through the roots that are sticking to the side. Going around the container a couple times with a repotting sickle will allow the tree to be removed much easier, as there are no more roots sticking to the sides to hold it in place. Other tools can be used to do this, such as a simple kitchen knife, but the curved shape of a repotting sickle takes this difficult task and makes it a simple process that can be done in less than two minutes.

Root Rake: A root rake is used on the roots of a bonsai tree after it has been removed from its container. The roots are going to be a messy tangle when the tree is first removed from the container. Using a root rake, this tangle can easily be worked out so that the roots are easy to work with when it is time to put the tree into the new container.

Other Tools Used in Repotting: As discussed above, a pair of bonsai shears are useful in repotting, as they can be used to trim the roots after they have been properly raked. A trowel for digging into the soil in the new container can make the experience easier. You will also want to purchase a pair of chopsticks, which are used to collapse air pockets in the soil and are generally one of the most versatile tools a bonsai gardener can purchase, despite not being designed for bonsai use.

Plucking Conifers

Conifers don't produce leaves the way other types of trees do. Instead, they produce needles. These needles can't be cut away like a leaf can and so instead you need to pluck them away. All you need for this is a decent pair of **tweezers** to get the job done, although you are better off purchasing a pair designed for use with pine needles. Plucking pine needles is done for the same reason that leaves are removed from other trees—energy is sent to the needles attached to the tree and removing some can help the tree to distribute that energy better. They are

also removed often for aesthetic reasons, as is common in bonsai gardening.

The Tools Used for Shaping Your Bonsai Tree

While pruning and trimming are important steps in shaping a bonsai tree, it is done to remove elements of the tree rather than to reposition them and change their shape. In order to do that, we need to use tools for wiring and bending. It is through the use of these tools that the most complex and striking bonsai styles are achieved.

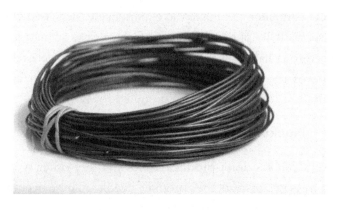

Wire: There is nothing written in stone that says you need to use wire on your bonsai. If you are growing a formal upright style, then you won't need it at all. Plus, you could technically use another material such a hardy fishing line to wire your tree if you had to. However, the most commonly used material is anodized aluminum. Aside from it being a well-priced wire, the fact that it has been anodized makes it a great choice. Anodizing is an

electrochemical process which is done to the aluminum to give it color, make it more durable, give it protection from corrosion, and create an anodic oxide surface which further protects the wire. While this may sound like it makes the wire more expensive, anodized aluminum wiring for bonsai trees can be purchased in packages of different thickness for under $20. More or less thick wire is used depending on what needs to be wired up and how much resistance there is for the wire to keep in check.

Wire Cutters: If there is one type of tool that bonsai gardeners are known for; it is the wide variety of cutters that they use. While you may think that the shears from above are more than enough for this job, you would be mistaken. Wire is a metal, and this requires a specially designed tool to cut without damage. When a tree is wired, it runs the risk of having to deal with wire bite. This is a process that happens when the tree starts to grow around the wire itself. This is unhealthy for your tree and it makes it hard to get the wire back out. Ideally, wire should be removed by hand; but when this is impossible due to wire bite or other circumstances, then it is time to pull out the wire cutters. A proper wire cutter has a rounded head that lets the cutters get close into the bark of the tree without actually cutting it. Shears and other tools that people substitute for wire cutters aren't just at risk of being damaged when used this way, they are also at risk of cutting the tree without intending to. Wire cutters are one of the tools that you should

absolutely invest in if you are going to be doing any work with wiring at all.

Branch Bender: When it comes to shaping the bonsai tree, wiring will be your go-to method nine times out of ten. But when those branches are particularly thick, wiring just isn't going to cut it. When this is the case, a branch bender is used. The branch bender is placed onto the bench and then a bolt is twisted to create a bend in the tree. A proper branch bender is adjustable so that it can fit onto both big or small branches, although it would be expensive (and unattractive looking) to use a branch bender on every branch. One or two branch benders are a great addition to a bonsai gardener's toolkit. Attach it, set it, and then remove it once the branch has grown to accept the bend you desire. When used properly, a branch bender can give you really stunning bends that change the feeling of your bonsai tree.

Pliers: While it may seem too simple, a pair of strong pliers work quite well for bending branches. Even more so when those branches are small and stubby, as a branch bender wouldn't have enough space to create the same effect.

Branch Jack: A branch jack is similar to a branch bender, but it is more often used for bending the trunk of a tree rather than a branch, despite the name. Attach the branch jack to the tree, and then tighten it to create a bend in the trunk. Once you have the jack in the

position you want for your new bend, use wire to hold it firmly into place and then remove the jack.

Branch Splitter: Like the branch bender or the branch jack, a branch splitter is also used for controlling the shape and adding curves to your bonsai tree. Each one can be considered as an improvement on the last in terms of how large the branches or trunks they are able to bend. A branch splitter is used for the thickest branches of them all. The jaws of the branch splitter are clamped onto the part of the tree that is going to be bent. The blades at the end of the jaws dig into the branch or the trunk so that you can then twist the tool to split the wood. This is then repeated along a section as necessary so that you can split, divide, or twist the wood more easily into your desired shape.

Chapter Summary

- Bonsai gardening uses a lot of tools for very specific jobs. You could purchase all these tools if you really wanted to, but a good pair of bonsai shears, a branch cutter, and a wire cutter should be enough to allow you to start.

- Tools can be expensive, so it is tempting to buy lower-quality tools. But lower-quality tools are heavier, quicker to rust, made of weaker materials and more prone to dull and chip. It is better to purchase high-quality tools that last longer and do a better job.

- The tools used in pruning are:

 o Shears, which are used to cut smaller branches and stems

 o Branch cutters, which are used to easily chop through thicker branches.

 o Knob cutters, which cave out the end of a branch after it has been cut so it heals properly.

 o Concave branch cutters, which are a combination of branch cutters and knob cutters.

 o Sealant which is used to help freshly cut branches heal.

- The tools used for repotting and root maintenance are:

 o A rooting sickle, which is used so gardeners can remove their trees from the containers.

 o A root rake, which lets you brush the roots of your tree like a hairbrush

 o Bonsai shears

 o A trowel for digging

 o A pair of chopsticks to dig holes and move around soil.

 ▪ A solid pair of tweezers designed for use with conifers makes removing needles a thousand times easier, but they're useless to those growing deciduous species.

- Tools used in shaping your bonsai tree are:

 o Wire, so the branches can be bent into place.

 o Wire cutters, so that you can remove the wire should it dig into the bark of the tree.

 o Branch benders, so that you can twist medium sized branches.

o Branch jacks, for those larger branches or even the trunk of the tree.

o Branch splitters, to split a branch to grow in two different directions.

In the next chapter, you will learn how to pick the perfect container to grow your bonsai in, what the best soil mixture you can get to provide plenty of oxygen and water, and how to pot and repot your bonsai tree when you first get it and as it gets older.

CHAPTER FOUR

PLANTING AND SOILING

Once you have decided on which type of tree you want to grow, you are going to need to plant it. In order to do this, you need to have a container and good potting soil with plenty of nutrients to keep the tree healthy. Plus, as we discussed briefly in the last chapter, there is also the task of repotting your tree once the roots have grown too much for the current container.

Not all containers are made equally, nor are all potting soils as effective as each other. Picking the right container and the right potting soil is necessary for the health of your bonsai tree, so we will now turn our attention over to these issues before moving onto the process of potting and repotting our trees.

Picking the Perfect Pot

When we first addressed the meaning of the term "bonsai", we learned that the literal translation is "planted in a tray". We've spent plenty of time on the styles, trees, and tools used in bonsai, but we haven't discussed pots at all yet. While they are key to the definition of bonsai, and even key to bonsai gardening in general, there isn't as much to be said about pots as you might expect.

Almost anything could be used as a pot for a bonsai tree as long as it has drainage holes. These small holes on the bottom are built into a pot so that water can properly drain instead of remaining stagnant on the bottom, increasing the moisture present in the soil and exposing the tree to sickness and pests that otherwise wouldn't be an issue. Most gardening pots come with drainage holes. However, a true bonsai pot has both drainage holes and wiring holes so that you can attach your wiring and hold it in place.

Pots used for bonsai gardening also come in a variety of materials, just like regular plant pots do. Ceramic, plastic, concrete, wood, glass, and terracotta are all materials that frequently pop up in discussions on plant containers. Each of these have pros and cons for you to weigh, and you should consider them all when it comes to most forms of gardening, but bonsai is a little different. The focus of bonsai is primarily on aesthetic presentation, and the pot is no different in this regard as it is one of biggest visual pieces of any arrangement. The most commonly used materials for bonsai gardening are porcelain or ceramic that has been stoneware burned to prevent the material from clinging onto water, which is the same reason that we go with a pot that has drainage holes. This covers the question of what the best material is to use for a container, but there are other attributes that the bonsai gardener should consider before selecting a pot.

There are three features which professional bonsai gardeners look at when considering which container to use. The first is whether or not the tree is masculine or feminine. Female trees tend to have smooth bark, fewer branches, and more natural curves; while male trees have older bark, thicker trunks, and more branches. Male trees are planted in deeper pots, which have clean lines and a thick rim to accentuate the features. Female trees are planted in pots with softer lines and they tend to be more shallow. Rounded pots can be used for both male and female trees. Most trees will have a mixture of both

male and female features, and these are tallied to see which side is more prominent. Keep in mind that this is an aesthetic consideration undertaken by bonsai artists.

The design of the pot is the second feature to be considered during selection. The design should fit with either the masculine or feminine features of your tree in order to create a more controlled look in which the tree and the pot both contribute to the same feeling rather than contrasting with each other. When considering colors, bonsai gardeners don't go for flashy tones. Instead, they look at the tree they are planting and select a pot that shares a color with the tree. This could be brown, tan, green, or any variety of earth tones. It doesn't matter so long as the tree also has it.

The third feature to be considered is the size of the pot. A rule of thumb used in deciding how large a bonsai tree's pot should be is to consider the trunk. When planted, there is a section of the tree which the Japanese call the *nebari*, which is the when the surface roots flare from the base of the tree. This is the section of the trunk just above the visible roots. A pot should be as tall as the trunk just about the nebari is wide. However, pots that are in the shape of rectangles or ovals will need a slightly different size and so should be two thirds of the trunk size. Square and round containers should be one-third. This easy to follow rule will ensure that you select a container with enough room for the roots to grow and thrive.

The goal in bonsai gardening is to create an arrangement in which all of the pieces (trunk, leaves, branches, pot, soil, shape, size) work together to create a feeling of harmony. When this is achieved, the power of a bonsai tree becomes clear. There is a sense of peace and a deep beauty to a bonsai arrangement that is in perfect harmony. So long as you select a ceramic pot with drainage holes and enough depth, your primary concern in choosing a pot should be to create this harmonic feeling.

Selecting the Soil

The first place a bonsai tree looks for nutrients is in the soil it is growing in. While fertilizer can provide nutrients later on, the soil you plant your tree in needs to have plenty of nutrients. The soil needs to be able to drain quickly so water doesn't get trapped, but it should also hold on to enough water to keep it from getting parched. It also needs to have enough space to allow oxygen to get to the roots. So long as you find a pre-made bonsai soil that checks off all these attributes, you are good to go. But soils like this are more expensive than they need to be, and you can save a lot of money by mixing your own. We'll first look at the difference between organic and inorganic soils, see the most common substances used for bonsai soil, and then quickly mix our own.

Premade potting mixtures for bonsai trees come in either organic or inorganic varieties. This refers to the

kind of substances which make up the mixture. Organic substances are composts and other plant matter like bark, anything that was once living counts as organic. Inorganic components are minerals like rocks or sand, substances which were never alive. Since organic components break down over time, this can leave a nice potting soil a ruined mess that doesn't properly drain. Organic mixtures also have a tendency to be worse at absorbing water. While you want excess water to drain off, a good potting mixture can absorb enough water for your bonsai tree to drink up and organic mixtures can have a hard time with this. Inorganic mixtures won't absorb as much water or as many nutrients, but they allow for plenty of drainage and oxygen to get at the roots and you can trust them to keep their quality since they don't break down over time.

We'll mix our own potting soil in a moment but before we do, we need to select the components that are going to go into it. We'll use a mixture of akadama, pumice and lava rock in others. *Akadama* is a type of Japanese clay that is baked prior to being mixed, and it is made exclusively for bonsai gardening. Akadama will start to break down after a couple years due to the process of baking it rather than being organic. While this can be a pain, the fact that it takes a couple years to break down makes it a little easier to deal with, since you should also be repotting your plant around this time. Pumice is a type of volcanic stone that is added to a potting mixture to help absorb water. Lava rock is

another volcanic store that can hold onto water, although it is difficult for roots to grow in lava rock, so it should be used in moderation. If you are growing a deciduous tree, then you'll want a mixture that is two-parts akadama and one-part each of pumice and lava rock. Coniferous trees on the other hand will want an even mixture of the three.

Take a sifting pan and use it to remove all the dust from your akadama, as it tends to wear away and produce a lot of dust when in the packaging. This dust is small enough that you might think it doesn't matter, but it actually clogs up the soil and makes it harder for oxygen to get to the roots as well as reduces the speed of drainage. Lava rocks also tend to have a lot of dust with them when packaged, so they should be sifted as well. With this out the way, toss your ingredients into a bucket and churn it all together. That's all there is to it! You now have a bonsai potting mixture that's ready to be tossed into your container.

Potting or Repotting Your Bonsai Tree

Bonsai gardening beginners are advised to purchase a bonsai tree from a reputable seller rather than try to grow their own from a seed. It isn't that it is impossible to grow a bonsai tree from a seed—far from it—but it is a million times harder and certainly well-past the skill level of a beginner. Because this approach is one in which you take your bonsai tree from one container and move it into another, it is actually an act of repotting. So, despite the fact that you are potting your first bonsai tree, you use the same steps here to repot it later on down the road as well.

If you have a repotting sickle, then the first step is to use it to remove any roots that have stuck to the side. Plants purchased from a professional seller shouldn't have any roots sticking to the container, but it is best to

be safe. If you don't have a repotting sickle, then you can use a kitchen knife to do this. Stick the kitchen knife between the soil and the side of the container and push it in all the way to the bottom. Work along the edges to make it easier to remove. You might find that roots are stuck to the bottom, in which case you will have to wiggle the tree free and clean off the dirt from the roots.

Now you should have a bonsai tree in your hand with the root ball exposed. Take your shears or scissors and cut off all but one third of the ball. Switch the shears for a rake and brush out the roots so that they are all exposed and there is no more soil clinging to them. Look for signs of rotting roots. Normal roots will be white or brown, while rotted roots will be black and have a disgustingly slimy texture. If there are any rotted roots, remove them now to promote a healthier tree. Again, a professional seller is unlikely to sell you a bonsai tree with rotted roots, but you never know. With the roots raked out and exposed, use a spray bottle filled with water to moisten them and make them easier to work with. You should also remove any roots that are just dead and any that are overly large and might prove to be an issue to plant.

If there are any dead branches or even branches that look ugly, remove them now before you replant the tree. Set the root ball into the soil in the new container and carefully position the tree. You can position your tree anywhere you want from here. Just be mindful that it is

more top heavy than bottom heavy, so if you do an extreme slant or anything weird like that, then you are going to have a hard time supporting it without wires. Pack in the soil around the roots and the base of the tree trunk and then add some gravel to the top to help weigh it down a little more. Water the tree once everything is in place. There you have it, you just moved your new tree into the container you picked out.

If you are repotting your tree, you follow many of the same steps. First, however, you need to know if it is time to repot your bonsai tree or not. How often you need to repot your tree is going to depend on the species and the size of the container that it is in. A species that grows quickly is going to need to be repotted every couple of years while slower species or older trees will fall into the three to five-year range. Despite these numbers, you shouldn't set a schedule but rather should pay attention and listen to your tree to know when it is ready. The best way to do this is to take the tree out of its pot near the start of spring and check the roots. When you pull the tree out, look at the soil. If it is primarily soil on the outside, then the tree is fine as it is. But if you pull out the tree and all you see is a bunch of roots wrapped around the entire structure, then it is going to need to be repotted that year.

It is best to repot a tree at the start of spring, because it will still be dormant and therefore it won't hurt it as much. Moving a tree from one pot to another

damages it. Us humans often suffer from relocation depression when we move, even if the move is a positive experience such as bringing us closer to family or a better paying job. Your bonsai tree could be thought of as going through this depression when it is moved, despite the fact that a larger container will allow it to stay healthier. By moving at the start of spring, you give the tree enough time for the roots to repair themselves before it is time to wake up for the warmer seasons and start growing again.

To repot a tree when it is time, you are going to want to remove the tree from the pot by using your repotting sickle to cut it free. A chopstick can help you to knock off as much of the soil as possible without hurting the roots. If you use a rake on the roots once they have been properly cleaned off, it is easier to brush through them. Roots that are too long, dead, or rotting should be removed with a cutting tool. You should never remove more than a third of the roots. Add in your bonsai potting soil to the new container and then add in the roots. Cover the roots with soil, place the trunk into position and then pack the soil in around it. Add some gravel to weigh it down and give it a proper watering. There you have it, pretty much exactly the same as your first time potting it.

Remember that repotting a bonsai tree is a traumatic experience for the tree. If you are going to trim any of the branches during the repotting phase, then do them

at the same time. It is better to get it all done at once then to repot it one day and then trim it the next. Give your bonsai tree enough time to recover from its trauma before you inflict more on it, otherwise your tree isn't going to live very long, which is a tragedy in its own right. If you are mindful of the damage and stress it is under and give it time to heal, then it will reward you by staying healthier, looking beautiful, and lasting longer.

Chapter Summary

- Proper soil for the roots to grow in and a container to hold it all are both critical components for bonsai gardening.

- You can use any material you want for your bonsai container so long as it has drainage holes.

- Specially made bonsai pots have wiring holes, which are used to help anchor the wires you use to adjust and position the tree's branches.

- The most commonly used material for a bonsai container is either porcelain or a stoneware burned ceramic. They will have enough weight to keep the tree in place while also draining quickly enough for the tree to stay healthy.

- The gender of a tree is used to describe the appearance. Trees may look completely male or completely female, but others will have features of both. When this is the case, the tree is referred to by which gender's features are the most prominent.

 o Male trees:

 ▪ Have older looking bark, thick trunks and plenty of branches.

 ▪ Are planted in deeper pots that have clean lines and think rims.

- o Female trees:

 - ▪ Have trunks with smooth bark with natural curves, as well as fewer branches.

 - ▪ Are planted in shallow pots with soft lines.

- Bonsai gardeners tend to choose earthy colors for their containers.

- The size of the pot should be determined by the trunk of the tree. The pot should be no taller than the trunk is wide just about the roots (the area the Japanese call the nebari).

 - o Rectangle or oval shaped containers should be no taller than two thirds of the trunk size.

 - o Square or round containers should be about one third the size.

- Bonsai soil needs to be quick draining with lots of space for water to move through. These spaces also allow for the bonsai tree's roots to get oxygen and breathe.

- We decided to make an inorganic bonsai potting mixture, so it quickly drains and lasts longer.

- A good potting soil mixture for a bonsai tree is akadama, pumice, and lava rock.

- Akadama breaks down after a couple years, but you should also be repotting your bonsai tree every couple of years so this shouldn't be a problem. Simply change the soil when you change pots, a step you should be taking anyway.

 o Deciduous trees use a mixture of two-parts akadama to one-part each pumice and lava rock.

 o Coniferous trees use a mixture of one-part akadama, one-part pumice and one-part rock to create an equal blend.

- Use a sifting pan on the akadama and the lava rocks to remove dust. This dust will slow down the speed of draining and block oxygen from getting to the rocks as easily.

- To repot a bonsai tree, follow these steps:

 o First use a repotting sickle to separate the roots from the container itself.

 o Pull the tree out and brush out the roots with a root rake. Look for disease while you do. Remove dead branches or those you plan to remove for aesthetic purposes.

 o Place the roots into the bonsai potting soil in the new container and pack the soil in enough to hold the tree in place.

o Water a repotted tree immediately.

- It is time to repot a bonsai tree if you see nothing but roots wrapped together when you pull it out from its container. If you see mostly soil, then it doesn't need to be repotted yet. Only perform this check when necessary, once every couple of years or so.

- It is best to repot at the start of spring just before the tree comes out of its dormant phase and starts to grow again. This will make the transplant less stressful for the tree.

- When you repot a tree that has outgrown its container, remove any roots that are too long or rotted. Never remove more than a third of the roots.

- If you are going to remove branches, then do it during the repotting. It is better to hurt the tree at the same time and then let it heal rather than to repot it only to come back the next day and start trimming. Shocking it more often is worse than shocking it once badly.

In the next chapter, you will learn how to tell when it is time to water your bonsai tree and how you go about it. You will also learn about plant nutrition, why you should be using a fertilizer to help your tree grow, what type of fertilizer you should be using, and how to apply it when it is time.

CHAPTER FIVE

FERTILIZING AND WATERING

Now that you have a bonsai tree planted in your container, you are going to need to maintain it. While one element of maintaining your bonsai tree is pruning and trimming, we'll be discussing this in a later chapter as it is a more involved process than simply keeping the plant alive. In this chapter, we'll focus our attention on watering and fertilizing our bonsai trees so that they continue to grow and show the world their healthy colors.

Everything You Need to Know About Watering Your Bonsai

Just like any plant, bonsai trees need to be watered at regular intervals. How often you should water them, how you know it is time to water them, how to actually water them, what the best time of day to water them, and whether or not bonsai trees benefit from misting are all questions that we'll be answering in this chapter.

81

As to the question of how often you should water your bonsai, the answer is that there isn't a single answer that fits each bonsai. In fact, there isn't even a single answer that fits each bonsai of the same species. Whether or not you live in a warm or a cold region will impact how often you should water, what kind of light you have on the tree (as this causes water to evaporate), how quickly the soil you are using drains, what season it is, and how deep the container you have potted the tree in are all variables which are going to affect how often you should be watering your bonsai tree. But one thing that can be said is that you will need to water your bonsai tree more often than you would other plants you are raising. This is because the containers used for bonsai trees aren't very big, so they don't take in a lot of water to start with; and the soil we're using is quick to drain, so it doesn't last very long either.

So, if there is no one set schedule for watering a bonsai tree, then the next question to be answered is how we can tell when it is time to water. To answer this question, we are going to need to do what is called the finger test. This is done by simply sticking your finger into the soil and feeling how moist it is. Different plants require you to stick your finger in different depths, but this test is used in pretty much all gardening that uses soil. For a bonsai tree, stick your finger in half an inch. If you have a bonsai tree of a succulent variety, then you are going to want to stick your finger in an inch or more. The goal of the finger test is to determine how much

moisture is in the soil. If there isn't any, then it is time to water. If you aren't sure whether or not the soil is moist or just cold, then pull your finger out and see if any soil sticks to it. If it does, then it is still moist and you can wait a little bit. Of course, generally you are only testing the top half-inch of soil, so there might be moisture if you go down too far and this could throw off your test. Always stick to the top half-inch of the soil unless you are growing a succulent tree; if you are, then you are going to want to err on the side of caution and allow it to get fully dry before you water it again. This is because succulents start to rot when they're exposed to too much moisture, but they are drought resistant and can therefore withstand (and even thrive from) exposure to dry conditions.

So, if you have done the finger test and it is time to water your bonsai tree, we must turn to the question of how we do this. There are two methods that are used for this. The first is the overhead watering method, and the second is the immersion method. Each bonsai artist has their own opinion on which is the better of the two, but there really isn't much of a difference when you get down to the science of it. Read about each of the techniques below and decide for yourself which is the better choice.

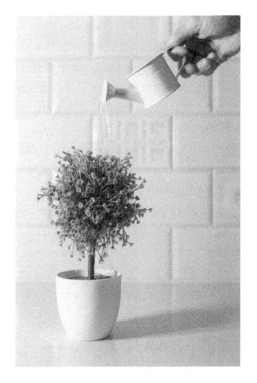

The overhead method is done by pouring water onto the bonsai tree in a light spray. It is important not to pour too much too quickly, otherwise the pressure may disturb the soil or any decorations that you have added to the topsoil. With this method, you don't pour water onto the soil. You pour it onto the top of the tree itself. The water flows down the tree and into the soil at the bottom. If you notice that there is water floating on top of the soil as you do this, then stop, allow it to drain into the soil, and then start pouring more. Keep pouring until water starts to drain out of the holes in the

container. Once you notice this, water your plant for another minute or so just to ensure that it gets plenty.

The immersion method is a slightly odder approach to watering when compared to the overhead method or how you would water a garden or a houseplant. This method is also best for indoor bonsai, though you could bring an outdoor bonsai tree inside in order to do this. Plug your sink and fill it up with water the same temperature as your bonsai is used to being in. You want to eyeball the water level and stop filling when it would come up to about an inch above the soil. Pick up your bonsai tree, container and all, and place it in the sink. You will immediately notice that bubbles begin to emerge from the tree. The more water that your tree needs, the more bubbles will appear. As you water your bonsai tree more, you'll grow to get a sense of exactly how thirsty it is by how many bubbles appear. If there are a lot of bubbles, you should water it more often. Likewise, if the bubbles are very slow to start surfacing, you should water it more often. Keep the bonsai tree under the water until no more bubbles emerge. Take your tree out of the water so that it can drain properly. Keep in mind that watering this way can damage the layout, wash rocks away, or even strip away fertilizer that was applied. Don't fertilize before watering; wait for the tree to drain and then fertilize. Also prepare for the possibility that you will need to redecorate the top layer of the soil, and this might take up some of your time.

So, you know how to water your bonsai tree, so when is the best time to do it? There isn't really such a thing as a good or a bad time to water your tree. That said, many gardeners express a distaste for watering during the hottest parts of the day as exposure to the sun can dry your plant out too quickly. But if your bonsai isn't exposed to the sun during the hottest hours of the day, then this won't matter. You don't need to get any special water either; the stuff that comes out of your tap will do just fine, although it is best to let the water sit for a night beforehand as this will allow any chlorine in it to escape prior to watering.

Finally, let's talk about misting. Many plants enjoy being sprayed with a light mist of water to stay moist throughout the day. Misting raises the humidity of the plant and can help some gardeners avoid purchasing an expensive humidifier. Misting also works as a shower for your bonsai to clean away gunk and bacteria from the plant, similar to the overhead method of water. Mist your bonsai by spraying the leaves and the foliage rather than the trunk and the bark. Misting should only be done lightly at one time. Indoor bonsai trees are going to require more misting, and they especially love it in the winter when they can really benefit from a higher humidity level.

If you follow these steps when watering your bonsai, you will have no problem providing it with the water it needs, when it needs it, and in the way that it

enjoys it best. Let us now turn our attention to fertilizing our bonsai trees.

Fertilizing Your Bonsai Tree

When a tree is growing in the wild, it has all the space in the world underneath it in order for its roots to grow and find nutrients. When the soil immediately below it has run out of nutrients, the roots stretch out far and wide to search for and soak up. If you've ever seen a tree with roots that spill out from it in all directions, then you have seen this process in action. Our bonsai trees are stuck in a small container, so there isn't any room for the roots to spread out and there aren't any extra nutrients to be found if the soil runs out. But bonsai trees need to feed on nutrients just as much as regular trees do. This means that it is up to us to provide them with nutrients, and we do this by feeding them fertilizer.

Fertilizer is primarily made up of three macronutrients that plants need: nitrogen (N), phosphorous (P) and potassium (K). When referring to most fertilizers, we use the element symbols NPK. Each of these macronutrients are necessary for plants to stay healthy. Although these three macronutrients are the most important elements in fertilizer, there are secondary macronutrients in the form of calcium (Ca), sulfur (S), and magnesium (Mg). While these are important, they are secondary when it comes to fertilizers. There are three other macronutrients necessary for growth (carbon, oxygen and hydrogen), but plants get these through the air and through being watered. There plenty of other micronutrients that go into fertilizer, like boron, copper, iron, manganese, molybdenum and zinc. While each of these has its own purpose and is useful, we're only going to focus on the big three (NPK) because they are the ones that matter the most and absolutely must be provided.

Your bonsai tree uses nitrogen in order to properly grow its leaves and stems. Phosphorus, on the other hand, helps the bonsai tree to grow plenty of strong roots. If your tree is one that grows fruits or flowers, then phosphorus will also help with this. Finally, potassium is a more general macronutrient which helps your tree to stay healthy. Most fertilizers are focused on the NPK balance, which is the ratio of these three macronutrients compared to each other. Some growers like to use fertilizers with different NPK balances at

different parts of the year, but this practice isn't actually very good for your bonsai tree, so you should instead aim to find the fertilizer that works best and then stick with it.

Fertilizer doesn't need to be applied during your bonsai tree's dormant months. Instead, start fertilizing at the beginning of spring when the growth season is beginning and continue fertilizing until the end of the growing season. The older your tree gets, the less often it needs to be fertilized; but in order to know when this is, research the species you are growing. This research should also be done in order to figure out exactly how often you need to fertilize your tree, though most plants are fertilized on a weekly or bi-weekly basis and some prefer a monthly schedule.

There are a lot of considerations which can be weighed when picking a fertilizer—the needs of the species, the price of the fertilizer, how it is NPK balanced (or isn't)—and each of these elements can make or break a fertilizer. It used to be recommended to use a nitrogen-centric fertilizer in the spring, moving into a balanced fertilizer in the summer, and a low-nitrogen fertilizer in the fall. This piece of advice has since become outdated, and instead it is better to go with an NPK balanced fertilizer that's mixed in a 6:6:6 ratio (that is 6 parts nitrogen, 6 parts phosphorous and 6 parts potassium). As the growing season starts to come to an

end, simply decrease how much fertilizer you are giving your bonsai tree rather than change the fertilizer itself.

An indoor bonsai tree is not going to experience the change of seasons the same way that an outdoor bonsai tree will. This means that indoor gardeners should keep fertilizing, even during the colder months because the controlled climate will prevent the tree from going dormant. Of course, a skilled indoor gardener might make the choice to mirror the natural ebb and flow of the seasons by dropping the temperature and altering how much light their bonsai tree has, thus making it go dormant. If you take this extra step with your indoor bonsai tree, then stop fertilizing it in this period as mentioned above.

There are specially made bonsai fertilizers on the market that you may want to consider investing in. These fertilizers are made with the same ingredients and nutrients as other fertilizers, but they are fine-tuned in order to provide the perfect NPK balance. These fertilizers, like fertilizer in general, can be purchased in liquid or solid form. While both of these are choices you should make based on your own desires, I will add my opinion to the conversation. I believe that liquid fertilizers are a better choice than solid ones because they are easier to work with and you have more control over how much to apply. I also believe that working with a specially balanced bonsai fertilizer is a good idea because they have been designed for this type of

gardening, so the manufacturers know exactly who the end user is, and this allows them to really niche down and get specific with their fertilizer. It is also a good idea to work with bonsai fertilizers because there are a few exceptions to the NPK 6:6:6 suggestion above, such as using a high-phosphorus fertilizer on species that flower or applying a low-nitrogen fertilizer to older trees that don't need as much help growing.

Purchasing a premade bonsai fertilizer will also provide you with the package the fertilizer comes in and this will have directions about its use which you should consult and follow. Since a bonsai fertilizer is specific to bonsai trees, you can rest easy knowing the instructions on the package definitely apply to your needs in this situation, whereas other fertilizers may be more concerned with the needs of vegetables, succulents, houseplants, or flower beds. Many growers use less than the recommended amount when first starting out to see how their plants handle it and then they increase it up to the recommended dosage slowly over several applications. Also, remember that older trees won't need as much, so they can be reduced as well.

To fertilize your tree, mix your liquid fertilizer with water as directed or pour it directly into a spray bottle if the label tells you to apply it as is. You can apply fertilizer as you are washing your tree, although this is best done with the overhead watering method. If you are doing the immersion watering method, then either apply your

fertilizer an hour or two ahead of watering so it has enough time to be absorbed before immersion or apply it shortly after while there is still a little bit of moisture left in the soil.

Fertilizing your bonsai tree might be a little bit of a hassle when you first start, but once you get down a rhythm it becomes second nature like brushing your teeth or combing your hair. The results in your tree's growth and health will easily make it worth the effort.

Chapter Summary

- Bonsai trees need to be watered, but how often you water it will depend on what species you are growing, how quickly the potting soil drains, and what material its pot is made out of.

- A bonsai tree will need to be watered more often if it lives in a hot climate. How much light a bonsai tree gets will also affect this since more light results in faster evaporation.

- Bonsai trees will need to be watered more often than most plants because of their tiny pots.

- The best way to tell if a bonsai tree needs to be watered is to perform the finger test.

 o Stick your finger a half inch into the soil and see if it is moist.

 o If it is then don't water it. If it is dry, then it is okay to water it.

 o If you are growing a succulent as a bonsai tree, then you are going to want to stick your finger even deeper because too much moisture will cause a succulent to rot.

- There are two ways of watering a bonsai tree: the overhead method and the immersion method.

o The overhead method pours water onto the bonsai tree from above so that it flows down the tree and into the soil. Water until the level of water in the container is floating above the soil and let it drain more. Keep pouring water and watch the drainage holes of the container. When water starts draining, pour for another thirty to sixty seconds and then stop.

o The immersion method involves filling up a sink with water so it would be an inch above the surface of the soil. Place the whole bonsai plant, container and all, into the sink. Bubbles will start to surface and there will be more bubbles the thirstier the bonsai tree is. Keep the plant immersed until the bubbles stop.

• Both of these approaches, though especially the immersion method, may mess up the soil, rocks or decorations on the surface of the soil. Being careful will reduce this but chances are good you will be required to fix it every few times you water.

• You can water your bonsai tree at any time in the day, but most growers advise against watering when the sun is highest and strongest as this will dry the soil out too quickly.

• You may want to spray mist onto the leaves of your bonsai tree from time to time, even perhaps

daily, to help keep it clean and provide it plenty of moisture to raise the humidity if necessary.

- The roots of a plant stretch and grow outwards to find more nutrients in the soil. When growing in a container, we provide these nutrients by fertilizing our trees.

- Fertilizer is primarily made up of the macronutrients nitrogen, phosphorus and potassium. While these are the big three plants also need smaller amounts of the secondary nutrients calcium, sulfur and magnesium, as well as the micronutrients boron, copper, iron, manganese, molybdenum and zinc.

 o Plants also need the macronutrients carbon, oxygen and hydrogen but they get this from the air and the water.

 o Nitrogen helps grow leaves and stems, phosphorus helps grow strong roots and potassium just helps with growing and staying healthy in general.

- Fertilizer is applied to a bonsai tree during the growing season. There is no need to fertilize a bonsai tree during the dormant season.

- Most bonsai trees are fertilized once a week or once every two weeks.

- It is best to stick with an NPK balanced fertilizer and use it throughout the year. Growers used to

switch fertilizers depending on the season, but this has fallen out of vogue and isn't suggested often these days.

- An indoor bonsai tree is unlikely to register the changing of the seasons and so it may never have a dormant period. If this is the case, then it will need to be fertilized the whole year round.

- A premade bonsai fertilizer will be balanced for the specific needs of bonsai trees and it will have all the necessary micronutrients mixed in as well.

- Mix together fertilizer and water as directed on the fertilizer's packaging and follow this guideline when applying. Never add more than it suggests but you can start out at a lower dose to see how your plant handles it.

 o Give fertilizer enough time to soak through the soil before watering a bonsai tree with the immersion method.

In the next chapter, you will learn about the most important types of wires used in shaping bonsai trees, as well as how to figure out the thickness of the wire needed for the bend. From there you will discover the best times to wire your bonsai, how it is done, a couple different techniques, and some tips to avoid common mistakes.

CHAPTER SIX

WIRING TECHNIQUES

While bonsai gardening is set apart from other gardening through its focus on aesthetically recreating the natural feeling of a tree, it is further set apart through the action of wiring. The closest that traditional gardening comes to wiring is stringing tomatoes and cucumbers up to a trellis. Both of these actions use some form of wire or rope to achieve their desired outcomes, but those outcomes couldn't be more disparate. Wiring your bonsai tree is purely to create interesting designs and twists to the physical structure of the tree. Meanwhile, wiring up a vegetable plant to a trellis is done to give support to top-heavy plants so their fruit won't be tarnished.

In this chapter we will explore everything to do with wiring our bonsai trees. From a look at the types of wire used, the material and the thickness of the wire, what season is best to wire, how we wire a bonsai tree, and how we remove the wire, everything you need to know

to get started will be discussed below. We will even take a look at some tips and tricks so you can more confidently control your tree's appearance.

What Type of Wire to Use

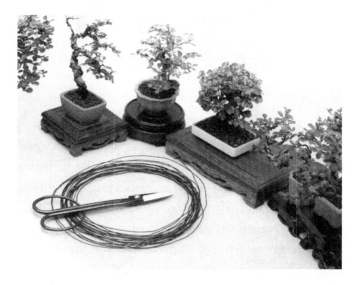

We briefly discussed what material the wire we use in shaping bonsai branches should be made out of in chapter three, and anodized aluminum was the metal of choice. Generally speaking, there are two key choices for wire: anodized aluminum and annealed copper. Some bonsai artists will use stainless steel, but this is only really appropriate for when you have to create a tough bend in a part of the tree that is especially thick. For now, stick with either anodized aluminum or annealed copper.

Anodized aluminum comes in black or earth tones like tan or brown so that it blends in with your tree. This is the result of the anodizing process discussed previously. Since aluminum is quite soft, it makes a great choice for beginner bonsai artists because it is easy to remove; and therefore, mistakes made with anodized aluminum wire can easily be fixed. Since anodized aluminum is so soft, it is the best choice for dealing with olive trees or elms which have a softer bark that can easily break under the pressure of a harder wire. This is also a negative, however, as anodized aluminum is not very strong and there are plenty of cases where a bend didn't take despite plenty of time spent on it.

Annealed copper wire is a softer version of copper wire, and this is important to note up front. Regular copper wire is too tough and it would damage the tree, so it is necessary for it to be annealed prior to use with bonsai trees. The annealing process is what happens when copper wire is heated up enough to soften the metal wire; and while there are ways to do this at home, it is best to go with a professional annealed wire. Even after the annealing process, copper is a stronger wire, and bends are more likely to take hold when copper is used as compared to aluminum. On the flip side, this means that mistakes made with copper wire are much more drastic and harder to fix. The softness of aluminum allows the wire to be bent and re-bent over and over again, while copper can only be bent a couple times before it starts to stiffen and is no longer usable.

If you have serious bends you want to make but you are nervous about working with copper, then one way to make it easier is to first bend the branch into the shape you want with aluminum, reinforce it with copper, and then remove the aluminum.

Wire comes in a variety of different sizes, and it is important to select the right size for the job at hand. Anodized aluminum wire and annealed copper wire have completely different properties, so the size right for one type of wire is not always the right size for the other. To help you select the perfect size wire for your tree, we'll look at both.

There are two rules of thumb which bonsai artists live by when it comes to using anodized aluminum wire. The first is that the wire should be roughly two thirds of the size of the branch in question's circumference. Remember, this is a rough estimate and you don't need to bother measuring. The other rule of thumb is that the wire should not be thicker than the branch in question. Together, these two rules tell us that it is okay to be over or under two thirds of the circumference, but that we should never be over. Remember that aluminum wire is quite soft, so one way to tell if your wire is too thin is to bend the branch into position and then check it a few hours later. If you notice that the branch has begun to bend itself back into its original position, then you know that the aluminum wire was too thin.

But waiting until after you have already made a mistake isn't a particularly useful tactic when approaching any task, much less when approaching bonsai. Thankfully, there is a quick exercise that you can use to figure out if you are using a thick enough wire. Take a two-inch-long piece of aluminum wire in your hand. This piece can be attached to a spool of wire or it can be a scrap which you have left over. Hold the wire so that an inch of it is in your hand and the inch with the end of the wire is dangling. Find the branch you want to bend and press the free inch down against it. If the branch bends, then you are using a wire of the right size (most of the time). If the wire bends instead, then you need to use a thicker piece for the bend you are considering.

Since annealed copper wire is stronger than aluminum, you don't need to use as much of it. In fact, a rule of thumb for using copper wire is to consider the thickness of a piece aluminum needed to do the same job. If you know the size of the aluminum, you need then you can cut that in half to get the size of the copper wire you need. Another rule of thumb is that while aluminum is a good fit for deciduous trees, copper is the go-to material for wiring conifers. Conifers are notably tougher than deciduous species, so a stronger wire is necessary to properly control their branch growth.

The Best Time to Wire a Bonsai Tree

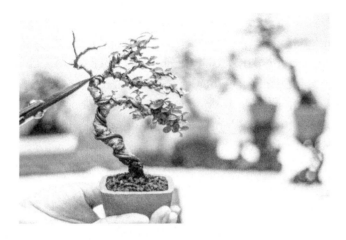

When it comes to deciding the best time for wiring there are two different categories, both of which need to be acknowledged in order to select the perfect time. These categories can be thought of as questions. The first question is, "When is the best time to wire a bonsai tree?" The second question would be, "When is the best time to wire a deciduous or a coniferous tree?" Combine the answer to both of these questions and you will have your perfect time.

Starting generally, it is best to wire a bonsai tree when it is younger. The older a tree gets, the more ineffective the wiring will be. Wiring should be done on a young, growing tree so that it has plenty of time to take to the shape and adapt. Then, as it gets older, there is no need for wires because it is in the desired shape. It is best to wire a bonsai tree just after it has been repotted. As it is adjusting to a new home, it can then adjust to the

wiring and so it connects these two traumas together as one.

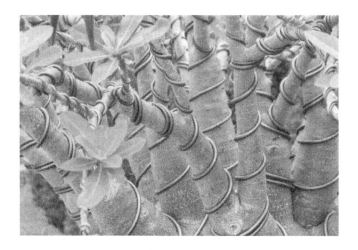

It is also important to note when a bonsai tree shouldn't be wired. If your tree is unhealthy or sick, then avoid wiring. Instead, give it time to heal and treat any diseases that may be present before you worry about wiring. Also avoid wiring branches that are weak. If a branch is weak, then you are better off giving it time to heal and strengthen again before it undergoes the stress of wiring. If you have just watered your bonsai tree, then you should wait before wiring it. It is going to be much less flexible when it is drinking up a bunch of water. Allow the tree to start to get dehydrated so that branches flex and bend more readily. Waiting for dehydration will lead to less broken branches or damage from cracking.

Looking first at the deciduous trees, the best time to wire is in the spring at the start of the growing period.

You want to wire the branches before the first buds start on them. The leaves have yet to come back in, and this makes it easier to imagine what the final product is going to look like. The branches will also be nude, and this means that it will be easier for you to get in and work with them as you won't have to try to maneuver around foliage or stems.

A coniferous tree is better off being wired at the end of the fall or the start of winter. Since the coniferous continually grows new needles, you won't be able to work with nude branches like you do with the deciduous. The purpose of wiring at this time has to do with the inside of the branch rather than the outside. Coniferous trees are filled with sap; and the more that there is present, the less flexible the branches are going to be. The end of fall or start of winter marks the point in the year when a coniferous tree has the least amount of sap present, so it is the easiest time to wire the tree at this point.

How to Wire and Bend a Bonsai Tree

So, why and how does wiring work to reshape a bonsai tree? The question of "how" is going to take a little bit of explaining to do. This section will cover the rules to follow when wiring a bonsai tree. You will also learn how to do both double-wiring and single-branch wiring. Let's get the why of it out of the way first.

Just how exactly does wrapping a tiny bit of wire around a branch give us the ability to shape a bonsai tree to our designs? Once the wire is in place and a branch is bent, there is a battle of tension going on. The metal wire wants to hold its new bent shape and it doesn't care that there is a branch trapped between it. The branch, on the other hand, wants nothing more than to fling off the wire and go back to its normal position. If the tree branch wins this battle of strength, then you need to use a thicker wire in order for the bend to work properly (or possibly one of the stronger tools covered in chapter three).

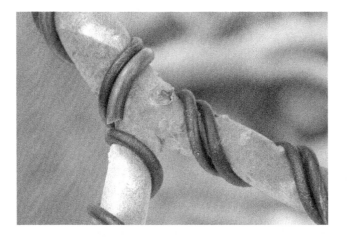

So, once you have decided on the size of the wire you are going to be using, it is time to start wiring. First, before you touch anything, take a look at your tree. Identify where there are branches of the same thickness close together. You are going to wire these branches together with a single piece of wire. Any leftover

branches without a similarly sized buddy are going to be single-branch wired.

Before you bend a branch, you should already have all of the branches you are planning on bending wired. If you are just working on the branches, then start with the branches that are being double-wired before moving on to the singles. If you are also wiring the trunk then start with the trunk before the branches. This will get the most difficult pieces out of the way first, as well as properly distribute the tension throughout the wire.

Regardless of whether or not you are wiring one branch or two, the wire doesn't begin at the branch itself. The wire is wrapped around the trunk of the tree from the back at a 45-degree angle and then brought around the branch (or branches) that you're wiring. The weight of the trunk of the tree gives the wire its resistance and supports all wiring techniques.

Turning first to the primary branches that are being wired together, you are going to want to select a piece of wire equal to a little more than twice the length of the branches (plus twice the circumference of the trunk). It is a good idea for beginners to work with wire straight from the stool and to cut it after it is positioned, and you know the exact length required. When wrapping a branch, you start from where it connects with the trunk and then wrap around and around it all the way to then end. After the first branch has been wrapped, use the

other end of the wire to repeat the process on the second branch.

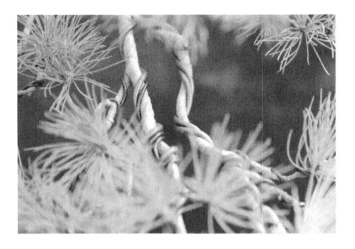

Single-branch wiring does this exact same thing, but the wire must be entirely wrapped around the tree at least twice to create a very tight hold. The single branches won't have the added resistance of a second branch and despite being less work to set up it actually makes them quite a bit harder to get to do exactly what you want.

When everything has been properly wired, you can finally start to bend the tree. Grab the branch you want to bend and just bend it. Don't need a tool for this, just your hands and probably a decent pair of gloves. Hold on to the outside of the branch in your fist and use your thumb to make the bend so that the force comes from inside of a well-held piece, rather than just snapping the branches and trying to bend them like sticks. Once you

get a branch into the position you want, stop touching it. Bending it a little doesn't hurt a branch that much but bending a lot does. While it makes sense to bend larger branches, you should also consider bending any straight sections on your branches to create a slight curve that looks more like what you would see in nature.

You can start shaping your bonsai tree now but before you do, let's take a look at some tips and advice.

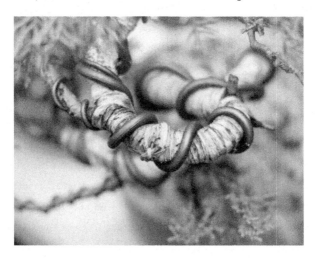

Bonsai Wiring Tips

With these tips in mind, you will be able to avoid the pitfalls that others have found themselves mired in and be well on your way to wiring like a pro right out of the gate.

Always cut the wire longer: If you think you only need five inches of wire to wrap around those two

branches, so cut six. It's better to have enough wire and lose an inch trimming it than to lose five inches because you miscalculated what you needed. You'll waste less wire this way, and that means you'll save more money in the long term.

Don't wire everything: When you first get into bonsai gardening and learn to wire, it is a lot of fun and you are going to want to wire every single piece of your tree. This isn't a great idea. For one, it's going to take a lot more time and effort. But for another, you don't need to twist your tree up that much. While wiring and bending is done to further mirror trees as seen in nature, having too many bends is going to create an uncanny valley effect that will leave your bonsai tree looking and feeling *wrong*.

Pay attention to the direction of the bend: Before you wire, think about which way the branch is going to bend. You can wrap your wire around the branch clockwise or counterclockwise; bending one way will be going against the clock and bending the other will be going with the clock. You want your wire to tighten and go against whichever direction the branch is bending so that there is a higher level of resistance to help hold the branch in place.

Wire downward branches from the top first: Wrap the wire around the trunk several times to make it nice and tight, and then wrap the branch you are pulling down from the top first. This will create more resistance

through the help of gravity, which is especially important because downward bends are the type that branches fight the most.

Don't even bother trying to double-wire distant branches: Two branches on opposite sides of the tree might be exactly the same size, but it doesn't matter. They make for horrible partners to double-wire. You need to wrap the wire around the trunk of the tree to hold it in place, and two on the opposite side would not create the tension necessary for bending.

Chapter Summary

- Bonsai gardening focuses on the aesthetics of the tree. Wiring is the process of attaching wire to a bonsai tree so that the limbs and even the trunk can be bent into aesthetically pleasing arrangements.

- The two most often used types of wire are anodized aluminum or annealed copper.

 o Anodized aluminum is the lighter of the two types of wire. It comes in earthy colors and it is very soft. Being a soft metal means it won't hurt trees with soft bark and it is easier for a beginner to work with to fix mistakes.

 o Annealed copper is softer than regular copper but harder than anodized aluminum. Use annealed copper for stronger branches.

 ▪ It is harder to fix mistakes made with annealed copper, so beginners are advised to plan out wires ahead of time using aluminum and then replacing it with copper once the size and position is known.

- The thickness of anodized aluminum wire should be roughly two thirds the thickness of the branch that is being wired.

- Wire should never ever be equally as thick as the branch it is being attached to.

- Anodized aluminum is soft and so it is important to check on bends a few hours after they are first wired. If the wire isn't strong enough to hold the tree in shape, then you will see it has begun to slowly bend back into its original position.

- To tell if a piece of anodized aluminum is thick enough to hold a particular branch you can perform a quick test:

 o Take a couple inches of wire, hold an inch of it and push the other inch against the branch you are going to be bending. If the wire bends, then it isn't thick enough. If the branch bends, then it should work.

- Since annealed copper wire is stronger than aluminum, you should only need the copper wire to be half the thickness of the aluminum that would do the same job.

- Conifers are a tougher tree, so a stronger wire will be necessary when working with them.

- It is better to wire a bonsai tree when it is younger. The older it gets, the less it should be wired. A young tree has time to heal and adapt. An older tree shouldn't need wires because it is already in the right shape.

- o Don't wire an unhealthy or sick tree. Only wire a tree that is healthy and hasn't undergone any recent stress.

- o It is better to allow a tree to dry before bending as a dehydrated tree is less likely to snap or break.

- A deciduous should be wired in spring at the start of the growing period.

- A coniferous tree should be wired at the end of fall so that there is less sap inside the branch. The more sap present, the harder it will be to bend it without breaking it.

- Wiring a tree allows you to bend the branches and the wire at the same time. The branch wants to return to its natural position, but the metal wire wants to hold onto the new position it has been bent into. If the wire is strong enough, it will hold the branch in place and the tree will eventually stop fighting the bend and instead start growing that way.

- For wire to stay bent, it needs to be anchored. A container with wire holes can be used, but the most common anchor is to wrap the wire around the trunk of the tree twice before it goes around a branch.

- Look for branches that are close together and about the same size. These are wired with the

same piece to create even more support for the wire.

- o Wire double branches first and then move onto the remaining singles.

- Measure your wire so that it is a little larger than the branch or branches being wired. Add this length to the size it takes to wrap around the trunk twice and cut a piece.

- Spiral the wire around the branches starting from where they connect with the trunk and going to the very tip of the branch.

- Once everything is wired, you can bend the tree. Make sure everything has been wired prior to bending any branches.

- Bent branches should stay in position but if they revert to the original position then you didn't use a thick enough wire. Some branches are too thick for wire and will require other tools to properly bend.

- It's better to cut the wire longer than you think you'll need. You can always cut off an extra inch or two after it has been wired. You lose less wire cutting off an extra inch than you do when you measure out six inches for a seven-inch job and the whole piece is useless.

- There is no need to wire every single branch. Instead, wire the major branches you are going

to be moving and try to work with the natural shape of the tree as much as possible.

- Think about how you are going to be bending a branch before you wire it so that you can wire it in the direction that will create more resistance to help hold the branch in its new position.

 o Branches that are being wired downwards should be wired from the top first to help create more resistance to support the new bend.

 o Branches that are too far apart from each other can't be wired together properly because they will lack the necessary resistance needed to hold a bend.

In the next chapter, you will learn how to prune and trim your bonsai tree so that you can take control of the foliage and the smaller branches, removing them as necessary to create more compelling and beautiful bonsai artworks.

CHAPTER SEVEN

PRUNING AND TRIMMING

While wiring is primarily about structuring your bonsai tree, pruning is done for both aesthetic structure and health benefits alike. The difference between pruning and trimming is whether it is for style (trimming) or health (pruning). The action itself is pretty much the same, but the reason behind the action is completely different.

Since pruning is done for health reasons, you should always prune away a problem when you see one. Trimming should be done less often, as making any cut to a plant always hurts it. In this chapter, you will learn how you prune for the health of your plant, trim to maintain its beauty, and how you take care of it after doing either one.

Pruning Your Bonsai Tree For Health Reasons

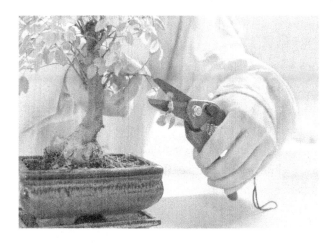

Pruning can be done anytime, and it should be done immediately upon discovering troublesome branches that are broken, infected, or infested. Node and crossed branch pruning should be done during the growing season, but they don't require immediate attention the same way that troublesome branches do. We'll take a three-step approach to pruning to remove any weeds that have taken root in the container and are trying to steal space from our trees, cut away the broken and crossed branches that are growing in unhealthy ways, and then we'll remove nodes to the branches to promote better energy usage.

The first step is to pull weeds and clean the tray. While this step is not technically pruning, it should be done whenever you are pruning your bonsai tree. By combining it into the same exercise, you can ensure it is always maintained. Weeds are going to steal away water and oxygen from your bonsai tree's roots. They will also

take up space inside the container, and this can lead to having to repot a tree early because the roots run out of room sooner than expected. The other important aspect of cleaning up is to remove dead matter from the tray, such as fallen leaves or dead branches that have broken away. Dead plant material becomes a nesting ground for annoying insects, pests, and deadly bacteria that can cause sickness and disease. Remove dead matter anytime you see it, whether by pruning or not. Removing weeds is a little harder, however.

In order to remove weeds, you need to dig through the potting soil, so you need to be especially careful not to damage the roots of your bonsai tree during this process. This is a good time to use a small tool like a chopstick to dig through the dirt. You want to make sure that you thoroughly remove the roots of the weed and not just the above soil foliage that is present, or there is a chance the weeds will grow again. Weeding a bonsai container is a time-consuming task because of the delicacy required, but it isn't a common problem when your tree is properly cared for.

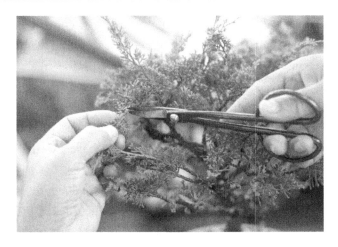

The next step is to look for any broken branches. Branches that have been broken aren't necessarily going to fall off on their own. Broken branches may stay attached to the tree, but they stop growing and instead just waste precious energy that the tree could be using to grow and heal. These should be pruned away with a cut just before the break. A broken branch will often look like a bent elbow and the stunted growth of the branch will indicate whether it is just a weird bend or a broken bend. Remember that gardeners who aren't careful can break branches during the bending phase themselves, so you may be the one responsible for the breaks you prune away.

Broken branches are bad for the way that your bonsai tree distributes the energy it gets from nutrients in its fertilizer, but crossed branches are even worse because they damage the tree and put its health at a greater risk. Crossed branches are okay for a little while,

but they rub against each other and this friction causes the bark to wear down and open up over time. Scrapes like this expose the vulnerable insides of the tree and give easy access to pests looking for a meal or diseases looking for a new plant to infect. Two branches are required in order to create a cross, but one of those branches will always be the aggressor. These are smaller branches which grew in such a manner as to cross paths with a much thicker branch. Cut these small aggressors as close to the trunk as you can. Leave the thicker, older branch alone whenever you have to fix a crossed branch.

The final step of pruning is to take care of the nodes on the branches. A tree first starts out as a trunk. The trunk then grows branches. Off of the branches grow nodes from which leaves or needles emerge. Without these nodes, a bonsai tree will remain plain and barren looking. But too many nodes encourage poor energy spending and can overcrowd a bonsai artwork and subtract from the overall feeling that the artist is trying to achieve. It is best to trim away nodes to keep them at a maintained level. Beyond just changing the flow of energy, cutting off nodes will encourage the tree to start growing mode nodes in different spots, so knob trimming will allow you to also greatly shape the appearance of the tree. Your tree might not grow leaves exactly where you want it to when you first start out, but knobs may spring up in the right places with time.

Allow a branch up to five nodes. Most bonsai gardeners allow an average of three nodes per branch, but there are styles which focus on only a single node across the whole of the tree. Regardless of how many you have chosen to keep, you should allow a tree to have seven or eight nodes on a branch before you cut it. When you cut the nodes, use either a pair of branch cutters or a knob cutter and cut the node as close to the branch as you can. You can keep a node on the tip of the branch and one on the beginning with as many or as little in between as you want. It doesn't matter the location on the branch that they are but simply that they share the same branch. Remember to do this for each branch.

Trimming Your Bonsai Tree For Aesthetic Reasons

It is best to trim for style during the colder months of the year when the tree is going dormant. This will give it plenty of time to heal and keep its shape before it is time to start growing again, and that shape could go in many different directions. Prune when a problem presents itself, trim for style when the tree goes to sleep in November (in the case of deciduous trees).

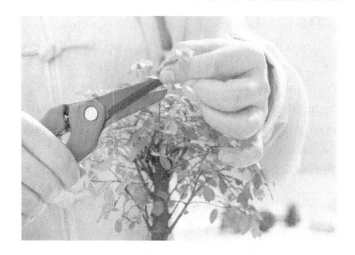

Start by identifying which branches you are going to be removing. Selecting branches ahead of time will allow you to plan out your cuts to make the job easier. If you have a hard to reach branch you want to remove that is blocked by another branch, it can be easier to remove the branch in your way so you can get a more direct cut on the blocked one. By looking at your cuts ahead of time, you can figure out the most productive approach. This is beneficial to the health of your bonsai tree because you have a much higher chance of poorly cutting a blocked branch, and this can lead you to have to make multiple cuts to remove the same amount of branch. It is always better to keep the number of cuts you need to make to a minimum.

Start by cutting the larger branches. Large branches are going to be harder to cut through than smaller ones and they take up the most space, so removing them will

make access easier going forward. You can also cut away branches which have weird turns or bad bends. The goal here is to remove branches which don't look right or which contrast with the emotional mood you are working to achieve with your tree. It is better to trim back branches rather than remove them entirely. Identify the nodes on the branch and make your cut just slightly past a node towards the tip. By leaving a node next to the end, you make the cut stand out less because leaves or needles grow right next to it and obscure it from view.

The next step is to trim away at the foliage to maintain a shape to the tree. Some styles don't require very much foliage work at all because the purpose is to create a wild appearance or to even completely remove all but the barest amount of leaves or needles. Other arrangements require very specific foliage needs, such as being cut to have haloes or bowl cuts that are evenly angled across the whole of the tree with no extraneous leaves to break the effect. It is also a good idea to trim the foliage a little to allow for light through to the lower sections of the tree.

To trim foliage, start by removing leaves at the stem. You can also remove twigs or small branches. Trimming away leaves and foliage doesn't cause nearly as much stress on the bonsai tree as trimming branches does. Branches are trimmed first as all foliage attached to it are removed with it. The remaining foliage is then shaped to

take care of the head of the tree. After that, we also remove suckers that have popped up throughout the previous growing season. Suckers are tiny pieces of bark that have grown off of the tree. You can usually remove these with your bare hands, but these are like a hangnail and will sometimes tear off strips of bark and wound your bonsai tree. A pair of shears can be used to create a tight cut and remove them without any harm.

The final step for aesthetic trimming is different depending on whether you are growing a deciduous or a conifer. While you may remove leaves for the purpose of shape, it is important to also remove leaves from a deciduous tree when they have gotten too old and long. We call this process "defoliating the tree", and it allows for new, healthier, and brighter colored leaves to start to grow in to replace the old ones. To do this, you cut away the old leaves, trimming the leaves at the base rather than

at the stem. By leaving the stem in place you encourage the tree to grow a new leaf from the same spot rather than move to a new spot. Removing a leaf at the stem will cause a new stem in a slightly different spot to grow; but defoliating will allow new leaves to grow in the same spot, so the tree should keep its overall shape. Research more about defoliating the particular species of tree you are working with because this technique can cause permanent damage if done at the wrong time of year.

A conifer tree, on the other hand, doesn't grow leaves but needles and so these can be pinched off in a similar fashion. Needles are twisted or pinched to reduce their overall size and create the most compact feeling to your bonsai tree. This shaping feels a lot like you are giving your conifer a haircut, and you can even use trimming scissors on it to deepen this feeling. Branches and sections of the conifer that have too many needles can be reduced by plucking out the needle whole rather than reducing its size. Leave three or four needles on each branch, but other than this you can trim or pluck as you see fit. These are left so that the tree has enough foliage in place to promote healthy growth and to keep energy getting directed throughout the branch so that it doesn't end up neglected and dead.

The trimming that we've covered in this section is mostly undergone for aesthetic reasons, but even cuts made for aesthetic purposes will have an impact on the health and energy distribution of the tree as a whole.

Keep this in mind when you make decisions about what to save, what to trim, and what to remove as a whole.

How to Care For Your Bonsai After It Has Been Pruned or Trimmed

Every time you cut your bonsai tree, you are hurting it. The cut itself will create an open wound and this has to be treated. But beyond the open wound, cuts send a shock through the system. Whenever you accidentally scrape your arm or accidentally cut yourself while working in the kitchen, you feel this same shock. It jolts through your body, wakes you up, and immediately grabs your attention. A little cut isn't so bad. A couple little cuts isn't going to kill you either. But too many cuts and the damage starts to be too much, and you get weaker and weaker. Your bonsai tree experiences this same reaction. The best way to take care of your bonsai tree is to consider this fact before you make any cuts and ensure that you only make the minimum number of cuts you need to in order to achieve the effect you are after.

But even when you do take the bonsai's health in consideration beforehand to prevent excess cuts, there are still going to be some cuts. These will need to be tended to properly to allow your tree to heal and recover fully without letting disease or harmful pathogens into the wounds. Open cuts on your bonsai tree are a quick way to allow sickness to ravage your tree and destroy your hard work. To prevent this, you must always plan

your cuts ahead of time and then treat these cuts with wound paste after.

We talked about wound paste briefly in chapter three while looking at the various tools used in bonsai gardening. We saw that wound paste is used to seal up cuts that were made to the tree. The best wound pastes are those that don't draw attention to themselves and aren't too messy during the application. A good wound paste should also peel off easily when it is time to be removed, and you can tell a cheap brand apart from a quality one by the way it flakes and sticks to the tree well past when it should. As the name implies, this is a paste that you rub onto the wounds of your tree. The paste prevents harmful bacteria from getting into the cut and it also keeps sap and other juices on the inside of the tree where they belong. Each brand of wound paste will include instructions on its use, but you will generally use a finger to rub it on the cut and create a seal. Wound paste is removed several days later, as instructed by the packaging, once the tree has had enough time to properly close off the wound itself.

One more note about wound paste before we continue with pruning aftercare: wound paste is useful for more than just pruned branches. If you missed a crossed branch and now have a bonsai tree with a big scrape on it, then you can apply some wound paste to help protect the tree while it heals. It can be used for any cut, scrape, or bruise that needs time to heal.

Returning to pruning aftercare, you should water your bonsai tree after you finish pruning. For one, we wait until a tree is dry before we start working with the branches as they will be less full. When it comes to bending, we wait for the dry period because the branch is less likely to snap. While this may seem like we would want a freshly watered plant for pruning since we're removing the branches, we want to have as much control over the cut or snap. Cuts on a freshly watered bonsai may cause more damage to the ends of the

branches; and this could create unsightly growths or require more wound paste to be applied, costing the gardener more in the long run. It is best to water after pruning a dry plant because it needs water in general and because it will start to drink up the water greedily to begin the process of repairing itself.

Continue watering the bonsai plant on a daily basis for the next half a week after pruning. These extra waterings will be much lighter and should only moisten the bonsai potting soil rather than soak it through fully. The extra water will help the plant to heal quickly, but too much water will create an unhealthy environment in which disease can easily grow. If you are worried about overwatering, then you can skip this step. This step speeds up the healing, but your tree will still heal without it so long as it is allowed to rest and recover.

You should continue fertilizing your bonsai tree after pruning, but you shouldn't go out of your way to give it any extra fertilizer. Try to give the tree a few days between pruning and feeding it any fertilizer. The healing process will have begun already, so the nutrients in the fertilizer will be put towards that with ease after a day or two.

Chapter Summary

- Pruning is done to remove branches that threaten the health of your bonsai tree, while trimming is undertaken to control and maintain the shape and appearance of the tree.

 o Pruning should be done whenever you spot a branch that can cause your tree harm, but node and crossed branch pruning are best done in the growing season.

- Before pruning your plant, first take a few minutes to remove any weeds that are growing in the container. Weeds take away space from your bonsai tree's roots and block it from getting as much water, oxygen and nutrients. Be careful removing weeds but always pull out their roots to completely remove them from the container.

- Look for broken branches when pruning and remove them a few inches before the break. Broken branches aren't a health danger, but they will waste energy the tree could be using on its healthy branches.

- Crossed branches happen when two branches grow too close to each other and they begin to scrape together. Remove the smaller of the two branches to prevent the bark of the tree from being scraped away to expose the vulnerable insides.

- Branches should have nodes removed to keep the total nodes per branch under five. Removing nodes promotes the growth of more and will help to keep the size, shape and energy consumption of a branch in order.

- Trimming should be undertaken during the dormant months of the tree.

- Start trimming by identifying the branches to be removed and making your cuts in the order that allows for the easiest access to all the parts being removed. Try not to cut a branch more than it needs to be.

 o Remove large branches first before moving onto smaller ones.

- Trim away any foliage that needs to be removed to achieve the desired shape. Remove leaves at the stem to completely trim them off. You should trim in such a manner so that light can still get through the foliage to the lower branches.

- If you are growing a deciduous then consider defoliating the tree by cutting away old leaves. Cut the leaves near the base of the stem without touching the stem itself. This encourages new leaves to grow from the same space as the old ones occupied.

- Conifer trees can have their needles plucked away or trimmed down for size to keep a more densely packed appearance.

- Apply wound paste onto any open wounds left from your pruning. Wound paste protects the open wound and prevents disease from getting in or sap from getting out.

 o Apply wound paste to bruises or scrapes from other causes such as crossed branches.

- Water a bonsai tree immediately after it has been pruned.

- You may want to consider lightly watering a bonsai for half a week or so after it has been pruned to help it heal but you must be careful with this extra step as too much moisture can lead to root rot and other diseases.

In the next chapter, you will learn that even after wiring, bending, trimming, and pruning, there is one more step to create the perfect bonsai arrangement: the way that the top layer and the tree is presented. This includes anything like rocks or moss added to the container, as well as how the container is displayed whether it be indoors, outdoors, in a display case, on a table, on the floor, or as part of a larger bonsai garden.

CHAPTER EIGHT

PRESENTING YOUR BONSAI

In this final chapter, we'll briefly consider the staging and presentation of your bonsai tree. This is one topic which could be expanded for pages and pages because what is considered proper presentation has changed and evolved over many centuries, and there is a historical depth to the topic that this book will be unable to capture. But for those who aren't interested in the history but rather just want to create the most beautiful display that they can, you will be happy with the tips and pointers in this chapter.

Before moving onto the more formal and traditional presentation tips, it is first worth pointing out that the true determiner of what looks best is going to be you. It may not be proper bonsai style to house your tree in a bright pink container; but if that is what you think looks best, then you are the one who gets to make that call. Consider these tips to be guidelines to what is typical, but they shouldn't be seen as hard and fast rules

that you must cling to in order to be a bonsai gardener. By this point, you already are one. The rest is simply flavor.

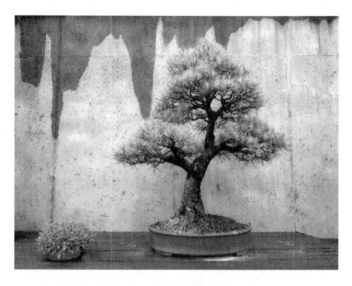

The Goal of Bonsai Presentation

The purpose of a bonsai tree is to recreate the essence of a tree as found in nature. To this end, most of the advice for presenting a bonsai tree aims to further achieve this purpose. A proper bonsai presentation should not bring attention to itself but rather work toward harmony, a sense that everything in the display is how it should be and how it would be if it were found in nature. Finally, a proper bonsai display is one in which every element present has been carefully considered and decided on. Those growing a vegetable garden or a flower bed in their yard may be used to letting the garden

do what it wants to. Often, this sense of surprise that comes from gardening is a wonderful experience. But bonsai gardening is all about controlling the bonsai artwork, so there is no room for surprises.

Each element that is included in a bonsai display is intended to narrow the focus on the beauty of the tree itself. A display includes the container the tree is housed in, the tree itself (which can be thought of as roots, trunk, branches, and foliage, since each provides its own effect), and the physical space in which the bonsai artwork is placed to grow. Every bonsai tree will have these elements, and many will have only these elements. But other common additions to a bonsai arrangement are Japanese scrolls, small and colorful plants, statues or rocks, or even miniature figures such as meditating monks or fishermen. We will now turn our attention to these elements in brief.

The Bonsai Container

We discussed the best container to use for your bonsai tree in chapter four. You learned that trees are considered to be either male or female depending on the texture of their bark, the curves of their trees, and the number of branches that they had in place. You then learned how containers are shaped and colored differently to match either male or female trees. This is done to help accentuate the natural appearance of your tree. You can find out more about these containers by revisiting chapter four.

Apart from the shape of the container, the color is the primary visual component that needs to be considered in an arrangement. Earthy colors are more likely to blend with your bonsai tree, which allows for the eye to be drawn to the tree itself. When you use a bright color like a pink or a blue, the contrast between the container and the tree inside is highlighted and this draws attention away from the naturalistic look, pulling the observer's attention towards the artificial nature of the arrangement. This is the exact opposite effect from what we are normally trying to achieve with bonsai gardening.

The Stand

A bonsai tree is meant to be looked at from eye level. If a viewer needs to crane their neck up or down in order to properly inspect the display, then the effect will be distorted. In the case of the forest style in which the audience is supposed to feel like they are in the middle of a thick wood, viewing it from the wrong angle will completely distort the effect.

A bonsai tree is traditionally displayed on a *shoku*. This is a stand that is designed to be the perfect height for a bonsai tree. Shoku come in many different shapes and sizes, and it will be up to you to match what fits both your tree and the space in which you will be displaying it. The color of the stand should accentuate the color of the tree and the container it is in. Some shoku will have a lot of design work done to give it an ornamental appearance, but this often distracts from the tree itself. However, when one wants to highlight the display, this can create a beautiful effect. Most bonsai trees look great when paired with a darker wood, but trees that grow blossoms pair beautifully with softer colored woods.

Adding Rocks and Other Decorations

A proper bonsai display is entirely focused on enhancing the natural beauty and traits of the tree, so most decorations are going to be added to further this effect. Miniature statues or scrolls are great additions because they capture the Eastern origin of bonsai gardening very well. Remember that you want to go with miniature decorations because they will help to keep the

scale of the tree clear. Some bonsai gardeners will add small buildings like miniature temples, and these can make a bonsai tree look much bigger through the effect of forcing a ratio.

Rocks serve a double use in that they are selected to add natural beauty to the bonsai display, but they are also used to weigh down the container, keep the tree firmly in place, and improve the drainage speed of the soil. While adding too many decorations will generally make a display look more tacky than natural, rocks are the one decoration that can be added in abundance without drawing too much attention away from the tree itself.

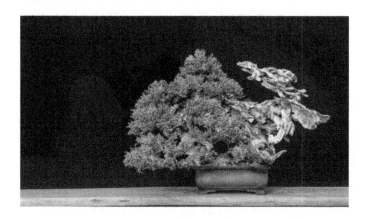

A Bonsai Display Table

A bonsai display table can be used either instead of a stand or with a stand, depending on the size of the table and the stand. If the bonsai is to rest on a carpet or any other material that could be damaged by water, then a display table will help to lift it up and offer spill protection. It will also look really professional and add a sense of class to a bonsai arrangement.

A bonsai display table added to a stand display should match the color of the stand's wood. If there is no stand then match the wood to the bonsai tree and its container. A bonsai display table shouldn't be very big, but the bonsai container should have enough space to rest in the middle of the display table with equal space on either end. A display table helps to center the bonsai display, and this effect can make a formal upright style tree really stand out. This centrality effect can also be used with a slanting style display to accentuate the lean of the tree.

Chapter Summary

- What is considered proper bonsai arrangement has changed throughout the centuries, but the most important critic in determining what is an aesthetically pleasing display is you. It is your bonsai tree after all and displayed in your home.

- Bonsai displays aim to reinforce the essence of the tree and create a stronger sense of naturalism.

- A bonsai display should not draw attention to itself but rather accentuate the tree.

- Every element of a bonsai display should be carefully considered and have a purpose. There are no surprises in a bonsai arrangement.

 o The best arrangements create a sense of harmony.

- A bonsai container is chosen to match the gender of the tree. A proper bonsai container should be in an earthy color that doesn't contrast with the tree's colors.

- Bonsai trees are supposed to be displayed at eye level and a proper bonsai stand, called a shoku in Japanese, stands at the right height. A stand shouldn't be overly flashy, and the color should match with the tree and the container.

- A darker wood stand matches most trees but trees that flower and grow blossoms can pair well with lighter ones.

- Decorations are added to the container to further the natural beauty of the bonsai. Miniature figures or statues can give a sense of the ratio and make a bonsai tree feel much larger than it is, much more like a tree in the wild.

- A bonsai display table helps to prevent damage from water spills and to bring attention to the centrality of an arrangement (or lack thereof).

FINAL WORDS

From tree species to potting soil onto wiring and pruning, you've just learned everything you need to start bonsai gardening and create beautiful organic artworks. You should also know how important it is to research the species you are working with to learn the specifics it requires. Much of the advice in this book is a generalization of bonsai gardening and works with a large majority of the species that are used for this ancient artform, but there are always exceptions to the rules.

The information in this book can take you well beyond the level of a beginner. You will need to get your hands on a tree to really put the information into practice, but this book can serve as a guide for many more advanced styles than those recommended at the beginning. You should still begin with one of the suggested styles like the informal upright, but you could create many of the more branch-heavy unique styles as time goes on.

Growing split trunks, forest style, or full cascade style bonsai trees will require further research from what was covered here; but if you are moving into these, as well as exposed root styles or rock and root styles, then you are already well on your way to being an expert. They wouldn't have been appropriate to cover in a book for

beginners, but they could be avenues for further learning if you find that you enjoy bonsai gardening.

You should now be able to tell the various bonsai styles apart from each other and understand the purpose of each of the tools used in bonsai. You also know the best soils and containers to use in bonsai gardening, how to make wiring as easy as purpose, and how to best trim and present your tree. With a little bit of practice in each of these areas, you will be able to grow gorgeous bonsai trees that are a joy to look at and make great additions to any household (as well as excellent gifts).

Remember not to spend too much money on tools when you are first starting out. While this is a relaxing and richly rewarding hobby, bonsai gardening isn't for everyone. You don't want to over-invest in a hobby before you know if you enjoy it or not. If you do find that bonsai is something you wish to continue learning, then you can use chapter three as a shopping list for all the different tools you will need.

It might not be the easiest form of gardening, but I am positive that you are going to find bonsai gardening is worth the effort. I hope that this book has made it easier to get started so you too can experience the tranquility that has kept bonsai gardening alive for centuries.